書旂畫法　　　張書旂　著

U0144012

TRADITIONAL METHODS AND TECHNIQUES

書旂到美先後二次，至今十有餘年，足跡所之，從學者衆，唯因時間短促，地域遼闊，未免顧此失彼，不能普及，而學者雅意殷殷，將何以應之，無已，緣作此書。

吾國畫法代有作者，唯多不脫文人積習，好高騖遠，故弄玄虛，以詞害意，致使學者不易領悟，求其條目理法秩然有序，足以爲津筏者，其唯謝赫之六法乎？

六法之道，一曰氣韻生動，二曰骨法用筆，三曰應物象形，四曰隨類傳彩，五曰經營位置，六曰傳移摹寫。自謝赫創此六法後學者翕然宗之，千餘年來莫之能變，即以今日眼光論之，亦殊合科學之理。唯鄙意六法應作五法，其第一項氣韻生動，應寫作繪畫之目的，實非法則。第二項以下則俱爲方法，因以求達其目的者也。此書本此意旨，所述筆觸及用筆二章，即骨法用筆是也；畫類及簡化二章，即說明應物象形之理也；色彩用墨二章，即隨類傳彩之意也；章法一章即經營位置是也；臨摹一章即傳摹移寫是也；此外另加用具渲染二章。至于氣韻生動旣屬繪畫之目的，而非法則，故不列入，將來再另當作書以發揚之。

吾國畫學浩如淵海，譬年執筆，皓首難工，決非此簡單之書可盡其蘊。今照歷年之經驗，引述最要之法則，文字力求簡易，插圖務求繁多，期能舉一反三，略得門徑，爲後日晉達之階耳。

In a country with ancient traditions, such as China, true originality must be built upon the methods and attainments of the past. There is perhaps no better way to open a discussion of Chinese painting than to refer to the *Hsieh Ho Liu Fa*, the Six Canons of Hsieh Ho. During the Northern Ch'i Dynasty this poet and critic formulated a set of principles governing the objectives and techniques of painting, and over the fourteen centuries which have followed, his Six Canons of Paint-

ing have been widely accepted. The Liu Fa, in the opinion of the Chinese masters, do not standardize the styles of scholarly painters, but offer a means of heightening and crystallizing their individuality. With a discerning and discriminating mind, an artist's technical skill must evolve to a high level before he is truly ready for self-expression. Then the brush becomes the medium by which he can interpret and express his inner feeling.

I shall attempt to condense and restate the Six Canons of Hiseh Ho in such a manner as to make them readily comprehensible. In the list that follows, it will be seen that the first canon has to do with the state of mind of the painter. The other five deal largely with methods and techniques. Each canon is in two parts.

Canon 1. The spirit of painting (Ch'i-yun), and rnythmic vitality (Sheng-tung).

Canon 2. Natural form and structure (Ku-fa), and the brush techniques employed (Yung-pi).

Canon 3. Depiction of a subject according to its nature (Ying-wu), and the brush and ink techniques employed (Hsiang-hsing).

Canon 4. Color (Sue-lei), and its application (Fu-ts'ai).

Canon 5. Composition (Ching-ying), and the selection of subjects (Wei-ch'i).

Canon 6. Study of classic paintings (Chuan-mo), and the copying of ancient masterpieces (I-hsieh).

The chapters that follow contain discussions of all these principles and procedures, but not always in the order of the canons listed. Rather than expound the canons, I have followed them in only a general way, setting forth simple outlines as a primary text for the art student. These may also supply information for those concerned only with art appreciation.

The first canon, rhythmic vitality, is abstract, and is regarded as the most essential feature in a work of art. It is difficult to define its import, because it is directed toward the spirit of the onlooker rather than toward his intellect. It may be said that its expression is a spontaneous outflow of the painter's own spirit. The painting reveals an artist's innermost feelings toward the forces that enliven every form in nature. Rhythmic vitality may be defined as the spirit existing in the rhythm of the universe. Through its use the artist tries to express

the creative essence, the soul, and not the outward form.

We must bear in mind that a work of art is creative rather than imitative. Deft skill and sure technique, as covered by the other five canons, will help the artist to attain his purpose, in creating a painting that gives the obvious surface meaning together with a profound inner message. Since he desires to express the essential essence of his subject through its outward form, the Chinese artist must always have its rhythmic vitality uppermost in his thoughts. His painting will have living beauty if it arouses emotion in the spectator, who thus becomes a collaborator.

Only when a student has become familiar with all six canons will he sense the intimate relationship between the rhythmic vitality that flows through all forms of nature and the living beauty of his creation. A good painting must always have this quality of creative beauty, revealing the spirituality of the painter as well as his profound mastery of the brush. This canon is closely related to the beholder, because discernment is dependent upon both his aesthetic and his imaginative capabilities. Traditionally, the Chinese artist is a scholar, a self-effacing man of culture, not a person concerned merely with pictorial representation. Thoroughly conversant with the history and traditions of his country, well versed in its poetry and other literature, he uses painting as the medium for expressing his awareness of all that is beautiful in the world around him.

It may be well to state at this point that I have no intention of writing an erudite commentary on the historical development of Chinese art, or the problems which have arisen druing past centuries. What I am trying to say comes from my long years of experience; I have confined myself to what I consider essentials, and shall augment the text with appropriate illustrations of my work. It is my earnest wish that the reader may learn the principles of Chinese painting, and be enabled to improve his work and increase his enjoyment of it, in whatever school he has been trained.

用具
PAINTING MATERIALS

一、筆，大約可分三種。甲，筆毛尖而不化開，可書可畫，凡拘勒之作，以及小點細莖，俱可用此。乙，筆毛化開，凡沒骨畫之粗枝大葉，俱可用此。丙，排筆或稱闊筆，爲塗背景而用。以上三種，除排筆有一枝已夠應用，其餘甲乙兩種，應備大小不同者各二三枝。

二、墨須用硯盆臨時磨而用之，不可用墨汁，蓋滯而不化，毫無韻味。

三、色，余用之色極爲簡單，即紅、黃、青珠、白粉、石青、石綠而已。紅、黃、青珠爲透明體白粉，石青、石綠爲礦質不透明。

四、紙，分生熟二種。生者爲宣紙，多韻味，唯不易畫，水多則瀋，少則枯。熟紙即礬紙，在國外，一切水彩畫紙或色紙俱屬此類，其性與絹本相同，擇其質稍粗而不光滑者，俱可作練習之用。

五、碟，可備二三隻，爲調色調墨之用。

六、盂，爲洗筆之用，瓷製鐵製均可。

Essential tools and equipment needed for painting in the Chinese manner are few: brushes, ink and ink-stone, water colors, paper, containers for paint and water.

Brusnes. Three kinds of brushes are generally used:

A stiff brush with a sharp point, made from deer, horse, or wolf hair, is used for calligraphy as well as painting. Such brushes come in three bristle sizes—long, medium, and short—and all will prove useful for outline work and for thin, fine lines and dots. To prepare this brush for initial use, dip the bristle in water to half its length only; then, holding the handle horizontally, gently loosen the tip by a slight downward pressure.

A soft brush, without a sharp point, made from goat, rabbit, or sable hair, is used for freehand work such as executing heavy branches, large leaves, and flower petals, and for applying ink or color. The entire bristle is softened before use.

A wide, soft brush with no point is used for background work or washes. One of these is sufficient unless the artist becomes involved with many large paintings.

Brush handles are always made of bamboo, as shown in the photographs on page 23. Brush prices range widely, depending on quality. The Chinese brush is a subtle and plastic instrument, extremely versatile and susceptible of an almost infinite variety of strokes. A skillful artist can manipulate it to produce lines sharp and concise, broad and quivering, light or dark, all according to the requirements of the subject. The pigment may be spread to strong strokes or thinned to delicate shades at his pleasure. Without breaking his stroke, he may change from a broad to a narrow line, from an irregular mass to a smooth and slender shading, and he may quicken or reduce his speed at will.

The ink and inkstone. Chinese artists mix their own ink. Prepared ink which comes in bottles should never be used, for it does not express fine shadings. Ink is prepared for use by grinding pigment from a Chinese black ink-stick or block. The ink-stick is made by impregnating gum with soot from pine smoke. Place a few drops of

water on an inkstone and grind the ink-stick against it. Two or three hundred turns of the hand, depending on the pressure, will make enough for immediate use. Fresh ink should be made at the beginning of each day's work.

The inkstone is flat and may be carved in various shapes, and with decorative patterns. Many beautiful ones have been made from early Chinese history, and these are precious to the collector. The novice, however, may use a simple inkstone which is not expensive. One of good quality should be washed clean after after use to preserve its fine surface.

Water colors. The following pigments are used: red, yellow, blue, orange, white, stone blue, and stone green. Transparent colors are red, yellow, blue, and orange. Opaque colors are white, stone blue, and stone green.

Chinese water colors are made in either pellet or powder form. Their dyes are derived from vegetable juices in some cases: yellow from the bark and sap of rattan, blue from indigo. Black comes from the soot of pine mixed with oil or gum. Some colors are obtained entirely from minerals: red from cinnabar and coral, blue from lapis lazuli, yellow from orpiment, white from white lead (poisonous) or burnt oyster shells. Chinese painters of long ago ground small white pearls for their white powder. All colors except yellow have an addition of animal glue which imparts a strong, characteristic odor.

These pigments may be used if the artist desires, but water colors made by Western manufacturers are wholly adequate.

Paper. Non-absorbent paper with a hard finish, treated with alum, is best suited for slow, detailed work. If Chinese paper is not at hand, use any water-color paper available at art-supply stores.

Absorbent paper, commonly called rice paper though made from cotton, has a fine, soft texture. It takes much practice and skill to paint on such a surface. If too much water remains on the brush, the ink or water color will spread when applied, making it difficult to draw the shape desired. On the other hand, if the brush is too dry, completing a stroke is difficult if not impossible. Only after experimenting with his brush and mastering the technique can a student learn to apply quick brush strokes on absorbent paper, with the spontaneity and suppleness of line so characteristic of Chinese painting. All strokes must be made rapidly and without hesitation, from beginning to end. The impression of spontaneity given by Chinese art is effected by the rapidity of the artist's brush strokes.

The earliest Chinese painting, before the invention of paper, was done on silk. Modern artists still paint on silk occasionally, but paper, because it is less porous, is better suited to either delicate or strong brush strokes. In China drawing paper is made form hemp, mulberry, and bamboo, as well as cotton.

Containers. Three or four small white plates will serve for mixing and testing pigments. They should be carefully washed after each use, so that colors are always clean. Any vessel that holds water can be used for washing brushes.

All the materials enumerated are available at Chinese shops dealing in paper and stationery items, and are usually found in large American cities.

用筆
HOW TO HANDLE THE BRUSH

要明用筆之道，須先知執筆之法。執筆有時用直，即中峯，亦稱圓筆，有時用斜，即側峯，亦稱方筆。大概平而扁之物體以用側峯較易表白，至於圓而運者，則以中峯為妙。作畫用腕力時則筆須握緊，若用指力則筆須放鬆。線條短或筆觸小者，可用指力，若線條長或筆觸大者，非用腕力不可。

用筆之法，須要輕重疾徐，未動筆前何處宜輕，何處宜重，何處宜疾，何處宜徐，應詳加考慮，待用筆時則應膽大，著手不能有所顧慮，所謂審察宜細心，用筆膽大。又曰磨墨如病夫，執筆如壯士，能如此，則意在筆先，筆不到而意則到也。

筆法大致可分六類。一曰神筆，縱橫妙理，變化莫測。二曰清筆，簡俊瑩潔，疏豁靈明。三曰老筆，如蒼藤古柏，峻石屈鐵，玉坏罅缶。四曰徑筆，如強弓巨弩，曠機蹶發。五曰活筆，筆勢飛走，乍徐還疾，倏聚忽散。六曰潤筆，含滋蘊彩，生氣藹然。此明代李開先所說者，特述之，為學者參考。

In Chinese painting the paper is laid on a flat surface at table level. Sit with good posture in a straight-backed chair. After preparing your ink and colors, it will be helpful to "play" with your brushes before you begin to think about painting. This preparatory exercise of the hand may lead the artist into a proper mood.

Hold the handle of the brush a little below the center. Place it between the thumb and first finger, resting the lower part on the nail of the third finger. The second finger rests on the handle just below the first. The thumb braces the handle.

The brush may be held upright, perpendicular to the paper when making dots and curved or straight lines. In this position the brush should be held firmly.

For making side-strokes, rectangular lines, and shallow, flat figures, hold the brush loosely in horizontal position, with the palm of the hand turned toward the

body. The stroke is made with pressure on the whole brush, from point to base.

Finger movements are used to manipulate the brush when making short lines, small points, and dots. The arm directs the brush in making long lines and heavy strokes. When painting a large picture, the artist should stand and lean over the table. This position enables him to make free movements of the arm and hand, and permits the whole body to work in coordination. Depending upon the subject, strokes are made either light or heavy, either fast or slow. The technique should be decided upon in advance, so that the artist may proceed with confidence.

There is a Chinese saying, "In planning be carefyl and deliberate, but when the brush is in hand show courage and self-confidence." Another offers further advice: "In grinding ink use slow, long-drawn-out movements, such as a weary person might employ in his labor; but when holding the brush, work as if you were a courageous hero." If the artist is to follow this advice and proceed in this manner, he must have planned the composition well in advance.

Since Chinese painting and calligraphy are sister arts, the Chinese scholar who paints is almost always an accomplished calligrapher, Our written language uses ideograms to express ideas not only accurately but artistically, and for this reason the works of our great calligraphers have been treasured throughout Chinese history.

Through assiduous study and long practice, the hand of the artist should acquire such facility in handling the brush that his mind and hand are left wholly free to express his thoughts. This is of the utomost importance, for strength or feebleness plainly shows in the stroke. Only after rigorous training may be gain firm and balanced control of the brush. He should take such exercises as these: press and lift, push and pull, turn and twist, dash and sweep.

Traditional ways of holding the brush.

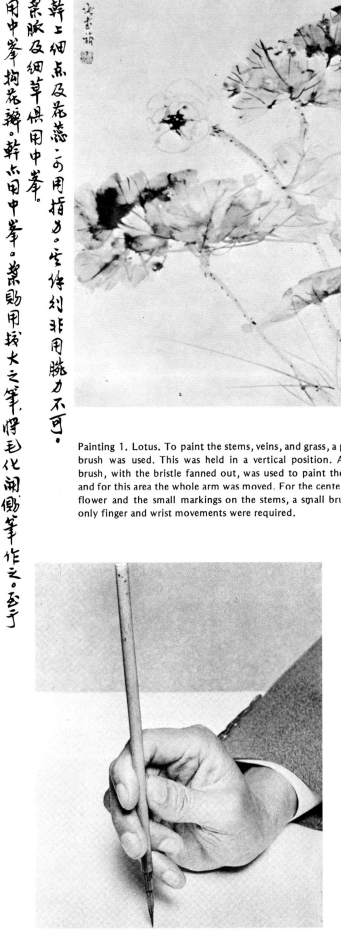

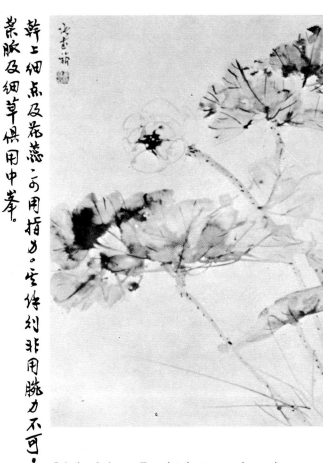

Painting 1. Lotus. To paint the stems, veins, and grass, a poi brush was used. This was held in a vertical position. A la brush, with the bristle fanned out, was used to paint the le and for this area the whole arm was moved. For the center of flower and the small markings on the stems, a small brush only finger and wrist movements were required.

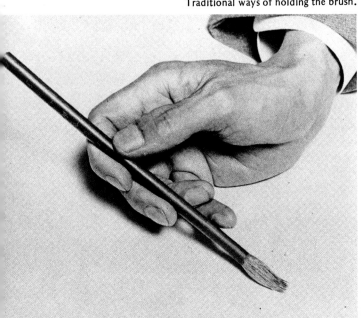

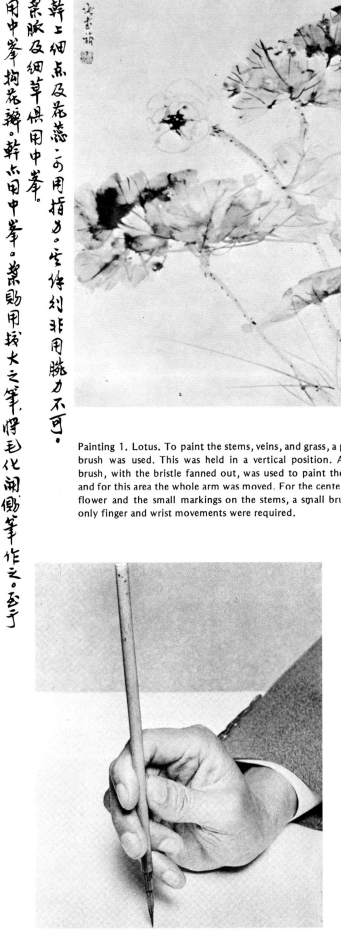

4

此老梅須用中峯，除点花心可以用指力外，空餘俱須用腕力。

旺李闓光所謨之老筆，如蒼鷹古柏，峻石屈鐵，玉坼走蟒，此畫約畧似之。

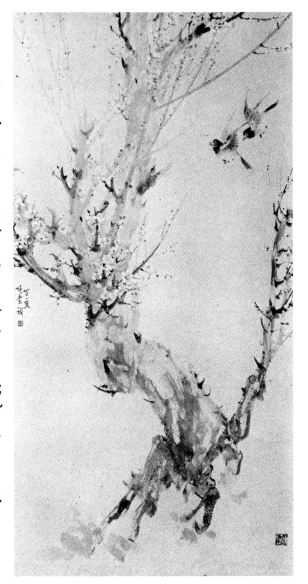

Painting 2. Plum Blossoms. The strokes depicting the tree trunk and branches were done in a vigorous fashion to express strength and virility. The blossoms and birds add decorative touches of color.

先將筆調水，次蘸墨于筆端，助筆端濃，筆根淡。

雞之腹部，腿部及尾部，以及錦葵之葉，俱亦用墨濃淡同時兼用之法。

三十六年作於西湖，浦江也禿聇

Painging 3. Rooster and Hollyhock. This illustration demonstrates the use of light and dark ink simultaneously. The technique is to be seen on the feathers of the breast, legs, and tail of the cock, and also on the leaves of the hollyhock. After the bristle was charged with water, just the point was dipped in ink, so that the stroke started out dark and became lighter as the whole of the bristle was pressed down.

用墨

PAINTING WITH BLACK INK

畫以墨為主，以色為輔，色之不可奪墨，猶賓
之不可溷主也。李成惜墨如金，王洽潑墨瀋成畫
；惜者骨疏秀，潑者氣磅礴，學者須明惜墨潑墨
四字。

古人云墨分五色。墨為黑色，何能分為五色？
蓋言其濃淡枯濕之不同，故可得各種不同之現象
。用墨須有乾有濕有濃有淡，近人作畫有濕有濃
有淡，而無乾，所以神彩不浮動，古大家荒率蒼
莽之氣，皆從乾筆皴擦中得來，不可不知。

至於濕筆可分二種畫法。甲、濃淡分別而用，
即先用濃墨，次加淡墨。如寫松針，先用濃墨作
針，次以淡墨水染之，以增其厚。或先用淡墨，
次加濃墨。如作山水，先用淡墨，積至可觀處，
然後用濃墨分出畦徑及遠近。乙、濃淡同時並用
，即先以水調勻筆毛，次加墨于筆端，則濃淡自
然融洽，沒骨花卉多用此法。

Great significance has been attached to ink painting in China for centruies. It reached its height during the Sung Dynasty (960 to 1279), and is still a mojor method of artistic expression.

There are five shadings of black ink, involving gradations of depth from jet black to light gray. These are dependent upon the amount of water carried on the brush, as follows:

Heavy black. To obtain this value a dry brush is dipped in the ink.

Strong black. A wet brush with the water squeezed out is dipped in the ink.

Medium black. Place a small amount of ink on a dish and add a few drops of water.

Light balck (gray). Use approximately half water and half ink.

Very light black (light gray). Use mostly water with a few drops of ink.

These gradations are used to show vitality, perspective, and spontaneity in a painting. Beauty of line can be expressed by their effective use. It requires great skill and good judgment on the part of the artist to produce the various ink values and tone qualities. Ancient scholars have felt that these gradations suggest all variations of color. Only a fine artist can express mellowness, richness, and softness in black ink.

There are two methods of using ink on a wet brush:

Heavy black and light black may be applied separately, to show dark and light objects. (*See painting* 6.)

They may be applied simultaneously. Dip the brush first in water and then in thick, black ink. Upon application the brush stroke is dark at first, and becomes progressively lighter. Or the stroke thus applied may show an interesting blending of light and dark throughout (*See paintings* 3, 4, 5, 7.)

A wet brush with light or dark ink is comparatively easy to manipulate, but a student may often have trouble with a dry brush at first. The brush should be dipped into ink, most of which is then removed by

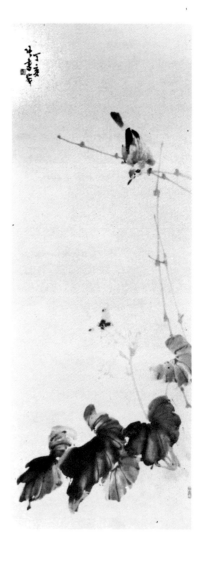

此二圖俱用墨水作成光將筆調水次蘸墨在碟內畧調不可過多方能部分
之部分。
寫濃部分各蘸淡且融洽調和不露邊痕。若于碟內多調助錄成淡墨坐濤

Paintings 4 and 5. Bird and Butterfly; Banana Palms. Here again dark and light ink have been used in combination. The entire bristle was dipped in water, and then just the tip was lightly touched in ink to produce the monochromatic shadings.

rubbing on a blotter or scrap paper. Strokes executed with a brush prepared in this manner impart·a mottled effect; they give a lifelike quality and spontaneous simplicity to a painting. A partially dried brush may leave parts of the stroke broken or open, but the continuity of idea is there. Differences in texture and shading, and the subtle nuances of ink tones, produce a most pleasing effect. Many old masters enjoyed painting in this manner.

Sometimes the outline of a composition is made with brush strokes using black ink, and colors are added as accents. Ink is often used sparingly in the outline, and darker strokes are added for natural contrasts. (See painting 27.) During the T'ang Dynasty Li Cheng used ink so sparingly that it was said that he saved it as if it were gold. His aim was the utmost restraint and simplicity. Wang Chieh, another artist of that time, used ink generously, and his work looks as though he had poured it on. He did this to show greatness, boldness, and character. The painter should understand these two points of approach. He will then know when it is appropriate to use ink profusely, and when he should be economical with it.

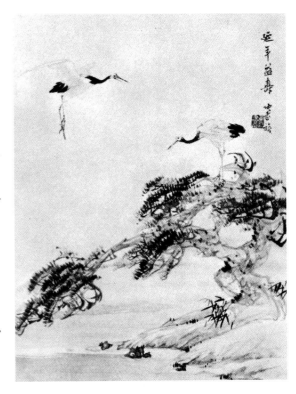

Painting 6. "Longevity." A light ink (black ink mixed with water) was used to outline the trunk and branches. Then a dry brush was applied for darker shadings. The needles of the pine tree were done in the strongest black. In painting each crane, light ink outlined the body and dark ink was used for the neck, tail, and legs. This is an example of the use of light and dark ink separately.

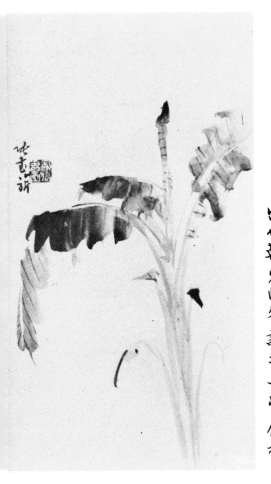

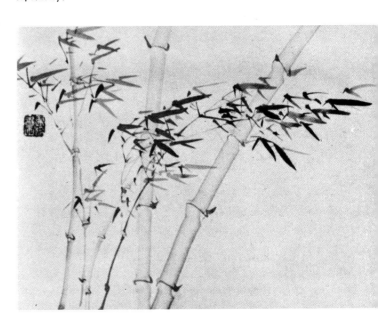

Painting 7. Bamboo. To paint the branches the brush was dipped in light ink, then the bristle was fanned out and dipped first on its left side and then on its right in a little darker ink. The illustration demonstrates the use of light and dark ink in combination.

7

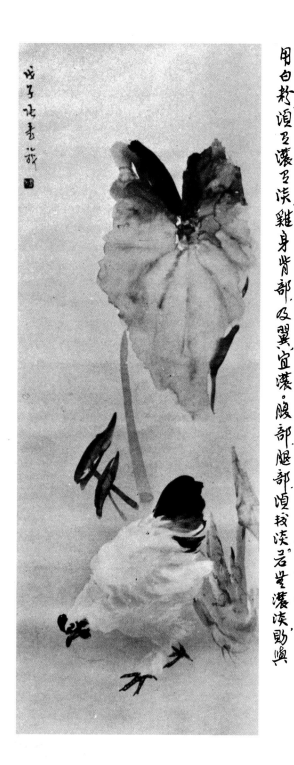

白粉不何常不可含多五色耶。雖在弓濃弓淡耳。

帝剪之團案何異。那能生動。學者應知用粉之道，要多用墨之法墨含五色，

用白粉須弓濃弓淡。雞身背部及翼宜濃。腹部腿部須挍淡君弝濃淡勛嚇。

(inscription on painting — vertical calligraphy)

Painging 8. Taro and White Hen. The bird in this illustration demonstrates a happy use of white pigment. Heavy white was placed on the back and wings of the hen, and lighter white on the other parts. Touches of grayed white were applied simultaneously to produce fluffy feathers.

用色之法
PAINTING WITH COLOR

　　用色之法可分單色複色二種。甲，單色即一筆觸僅用一種色彩。此與用墨之法無異，懂得用墨之法，自然能知用色之道，即先調水次調色，則筆端爲濃，筆根爲淡。或先調色次調水，則筆端爲淡，筆根爲濃。乙，複色，即一筆用二種以上不同之色。此與用墨相異。其法將筆先調某色，次加另一色，或又一色，則筆著紙時能現各種不同之色，具極自然，毫無痕跡。惟有一點須注意，即未著紙前，不能在調色碟調勻，否則成爲某一混合色，不能顯出數色矣。如青與紅調則成紫的混合色；若先調青後，僅于筆端加紅，則其結果部分爲青，部分爲紅，而非混合色。至于用粉，亦應如用墨之法，即須有濃有淡，切忌平塗，否則呆板無趣。

Chinese painting is known for its richness in the use of soft colors, which tend to subordinate all the elements of a picture into a harmonious whole. This is in keeping with the spiritual values desired by the Chinese. Their urge for a calm and tranquil spirit is satisfied by the quality of color employed by the old masters, who often indulged in color abstractions, a rendering of self-tones of a single color.

The student must learn the essentials of color mixing, color matching, and color application, both in producing monochromatic effects and in the use of many colors. Monochromatic painting with color follows the same technique that has been described for the use of black ink, on pages 27 and 28. Wet the brush in water and dip just its tip in color. On paper the first part of the stroke will show a deep color tone, with the lightest color at the base of the stroke, and with various shadings in between. This procedure can be reversed by charging the whole brush with color, then dipping its point in water. The ensuing brush stroke will show color in lighter tone at the beginning, gradually deepening with greater brilliance at the base. Subtle and exquisite nuances may be produced in this manner.

In the past, Chinese painters have not made much use of white, because they thought of it as a flat color with few nuances. However, highly effective results can be ogtained by using white paint on off-white or tinted papers. I have enjoyed painting with white, and have taught many students the following technique. Use white paint as you would black ink; in other words, strive for variations in tone, making some parts of the stroke heavy, other parts light. Do not apply it in an

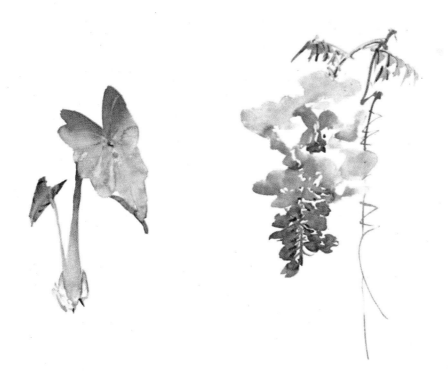

滾下部為青上部細下部粗矣。
如黄)次蘸紅色自上而下由輕而重則上部為
帝前二色不調勻。設法先將筆調青(可畧為
筆根為甘。至于左圖,設幹花紅青二色惟着
再以他筆調粉筆端蘸紫色贴筆端蘸紫,
右圖紫籐係紅青二色調勻成為紫的混合色。

Painting 9. Taro and Wisteria. The wisteria (right) is in shades of purple, made with a mixture of red and blue water color. A clean brush was charged with white water color; then the point was dipped in the purple and brushed onto the paper. For the leaf (left), a clean brush was charged with blue-green pigment, and just the point depped in red. The stem was painted starting at the top and moving toward the bottom, with the result that the upper part came out mostly red, the lower part mostly blue-green. The stroke was started with a fine, light touch, which gradually broadened into a heavier line at the bottom.

Painting 10. Leaves. These are four practice plates showing the combination of different colors in one stroke:

1. The bristle was first charged in yellow, then the point was dipped in red.
2. The brush was dipped in yellow and the point in blue.
3. The brush was dipped in red and just the tip in black ink.
4. The brush was first dipped in yellow, then in blue, and lastly just the tip in red.

For this technique it is most important not to mix the colors before-hand. If the brush is dipped into the colors separately, the colors will arrange themselves on the paper in blends and textures as the brush stroke is applied.

不能在碟內調勻各列成為混合色矣。
青末蘸紅。此畧注意者,所用二色或三色,
次蘸青三先調紅次蘸墨。⓪先調黄次蘸
種不同之象、一先調黄次蘸紅二先調黄,
所作之棠用各種不同之色遊現出為

9

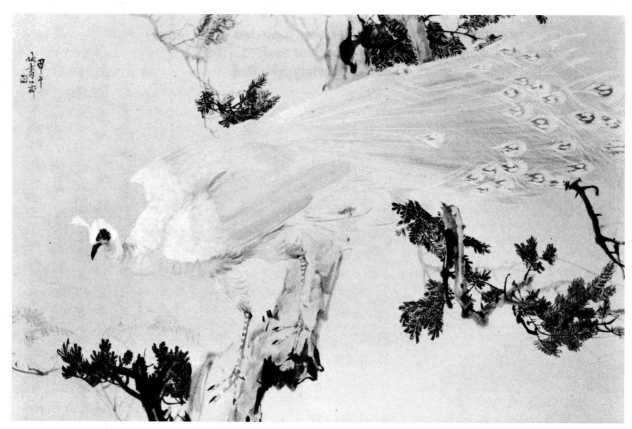

Painting 11. Peacock. White pigment and black ink are opposites, and, while old Chinese masters did not mix the two in the manner shown here, the combination may, nevertheless, be most effective. A tinted paper is recommended, for white pigment does not of course show up well on a pure white background.

沒骨畫。

為宜若用白帝品好用線條勾出之不能作白粉之加墨水始能顯出陰陽向背而用之帝以呈背景毛羽必曾參用此福孔雀之毛，雲灰色部分藍墨白粉典墨水二者相反不能混合唯至時作翎毛之

paint, and all of them will be brought out and blended. This mixing of colors will produce new tones and shades without distinguishing lines between them, and often the most intricate and exquisite shadings will be produced. It must be emphasized that the paints are not to be mixed in the dish beforehand if this effect is desired. But if the artist dips his brush in blue, and then in red, one portion of the brush stroke will be blue and another red, with a soft blending of both colors as well. The effect of these subtle transitional hues of red-violet, violet, and violet-blue can be attained only by the most skillful handling of the brush. (*See paintings* 9, 10, 13, 19.)

There is still another method of using two colors simultaneously which may prove effective. If you use a brush with a broad tip, with a different color on each side, the strokes will produce parallel lines which greatly accentuate the form and accent of an object. (*See painting* 7.) Wise choice of contrasting colors is obviously required for this technique, as well as brush mastery.

In Painting the feathers of birds, I have always tried to produce a fluffy and soft effect. After some experimentation I have found that the following procedure produces the desired texture. Place a little white pigment in a dish, add a dash of black ink, and mix them only partially, never thoroughly. Use of the half-mixed white and black produce luminous grayish tones which makes the feathers seem vibrantly alive. (*See painting* 8.)

even tone (just one shade of white), or the stroke will turn out to be stiff and flat. The intensity of white will vary according to the wetness or dryness of the brush. (*See paintings* 8, 11.)

Two or more colors can be used on the same brush and can be applied to the paper in a single stroke. Dip the damp brush lightly in one color, then in another, and even in a third or fourth if you wish. Moving over the surface, the colors may be mixed on the brush as you

石青石綠係礦質不透明，此幅之樹光用墨水寫成，次如綠色染之，待乾後，再加石青於雪工因不透明，故仍也顯明。

Painting 12. Cypress Trees. Here the trees are accented with stone blue, an opaque mineral paint. They were first outlined in light black ink; then when this was thoroughly dry the blue was brushed in, in small firm strokes. The scene in the background was washed in first.

Painting 13. Cinerarias. These flowers were painted with a brush dipped first in white pigment, then in blue, and next in red at the tip. The cineraria leaves were painted in a combination of brown, yellow, and blue pigments combined on the brush. Darker parts of the leaves have more blue, while the lighter have more brown and yellow.

畫此花用白粉花青胭脂三色筆根多紅筆端多青興黄，黑興紅故部分屬濃部分屬淡興用墨之法要些異，葉用青興黄，暗如珠濃要多用青濃淡則多用黄興綠。

中峰拘之。全畫俱須用腕力。當論墨水或色彩切須多用水分。方或淋漓老緻。此係没骨畫也。至花至葉須用較大之筆。至毛全部化用側筆作之。至于葉莖助用

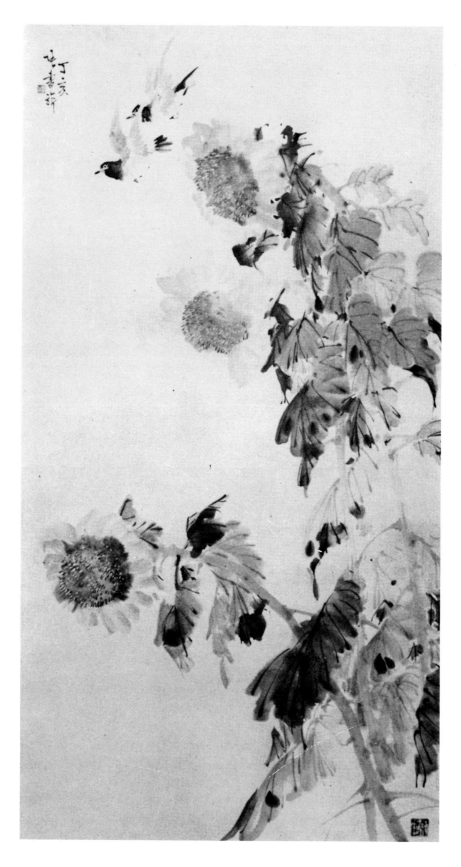

Painting 14. Sunflowers. An example of the Mo Ku method of painting. The sunflowers and leaves were painted with a large brush held in a slanting position with its bristle fanned out. For the veins of the leaves, the brush (slightly wetter) was held vertically, and arm movements were used.

畫之種類

STYLES OF PAINTING

畫之種類有各種不同之分法，若根據材料而言，則有油畫、水彩、色粉、墨水等等。若根據題材而言，則有人物、走獸、山水、花鳥等。若根據畫之跡象而言，則有：

(一)工筆畫，甚謹甚細。唐李思訓寫嘉陵江五日一山，五日一水，即工筆畫也。

(二)寫意畫，任意揮寫，不拘細謹。唐吳道子寫嘉陵江一日而成，即寫意畫也。今就畫之方法而言，則有拘勒與没骨二種，所謂拘勒，亦稱雙拘，即用線條先拘物形之輪廓，再加色彩或水墨，亦有僅用線條而不加墨水或彩色，則稱白描，故白描係拘勒之一種。至於没骨，則不用線條拘輪廓，直接用墨水或色彩畫成物形。一畫中可以部分用拘勒，部分用没骨，亦甚有意趣。畫者甚多。初學者應先從拘勒入手，待有相當技能再學没骨。

Painting 16. Baby Chicks. A Mo Ku painting. No outline was drawn in this case. Comparison with the young birds in painting 15 shows the wide difference in techniques.

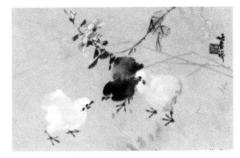

There are two basic techniques in Chinese painting, Kung Pi, which is stylized, and Hsieh-i, which the Chinese call the free-brush method. Paintings in the Kung Pi manner are characterized by great detail, and the work is done with slow, fine strokes of the brush. The famed T'ang Dynasty painter Li Ssu-hsun once painted a landscape called "Chialing Chiang" on which he worked for five days to complete the mountains, and as many more on the water. The result was a precise water color showing everything in great detail. (*See paintings* 23, 25.)

In direct contrast to the Kung Pi style, the Hsieh-i artist paints freely and boldly. He knows his subject well, and with the picture he wants to paint firmly established in his mind he executes it rapidly and with great apparent ease. Only essential details are shown, and the forms produced are full of spontaneity and life. (*See paintings* 24, 26.) In cortrast to the meticulous and slow

Painting 15. Mother Hen. An example combining the Mo Ku and Ke Le techniques. The hen was painted in Mo Ku style with a bristle brush fully fanned out. Working from head to body, dark to light gradations of ink were applied. Dark ink was then added on the wings and tail. The baby chicks represent Ke Le or outline painting. Here light ink was used to draw the simple outline, and color applied later in the enclosed areas.

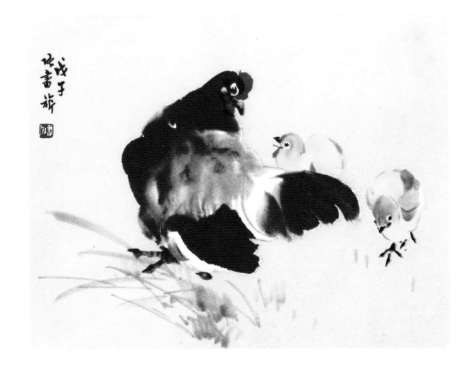

procedure of Li Ssu-hsun described above, another famous painter of the T'ang Dynasty, Wu Tao-tzu, took only one day to complete the same subject in the Hsieh-i style. According to the emperor who commissioned the two artists to portray the identical scene, both paintings were equally good. Hsieh-i may be said to be a free interpretation of nature. The artist must have a sure hand, and a memory trained to the highest point. He studies his subject, then paints from memory only what he considers the essential elements, using the fewest possible strokes. With complete mastery of his brush and his color technique, he will attain perfect coordination of mind and hand.

There are three other terms commonly encountered in discussions of Chinese painting techniques. These are Ke Le, Pai Miao, and Mo Ku. Ke Le involves drawing the outline of an object and then filling in the enclosed area with color. (*See paintings* 20, 27.) Pai Miao means deawing the outline without adding color. Mo Ku signifies a painting that has no outline work; literally

translated from the Chinese, it means a 'boneless" painting, but it is by no means as unattractive as this term sounds. The painter works directly with color or ink on his brush, without previously sketching an outline to follow. This method, which shows strength and elegance in the freehand strokes of the brush, requires a great deal of skill. In executing broad washes or masses, the painter concentrates on the essentials, a method diametrically opposed to the elaborate, detailed procedure followed in Ke Le or Pai Miao. (*See paintings* 14, 16, 18, 21, 22.)

Sometimes we find a combination of Ke Le and Mo Ku in one painting, and this can result in interesting contrasts. Often, too, we find that a beginner draws only the outline of an object, as a first step in learning. Later, when he is thoroughly familiar with the subject matter, he may paint it again freely, omitting the outline. Various combinations of brushwork, form, and color, all in one painting, produce fascinating results. Unity and variety, harmony and contrast, must always be borne in mind. (*See paintings* 15, 17.)

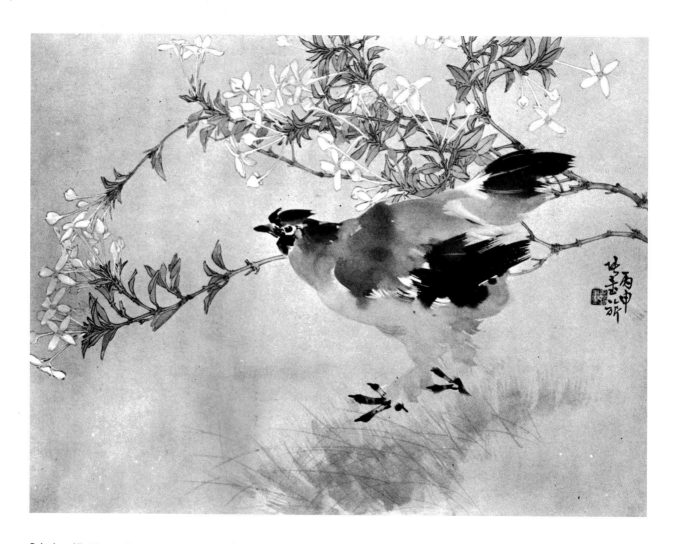

Painting 17. Hen and Bouvardias. Here the same technique was employed as for the hen in painting 15. The background flowers were first executed in outline. The detailed work on them, and the free-hand style employed for the bird, shows the Kung Pi and Hsieh-i techniques in combination.

雞屬沒骨宝畫法如前所述者玉于背仂之花則為沒骨七謹去細以形近言雞為寫意畫花則工筆畫也

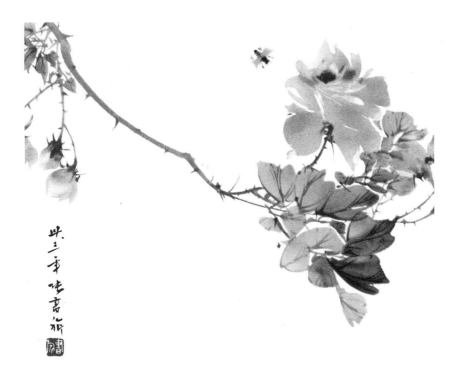

今嫩葉亦如珠與紅色。

故色亦可以同時并用之一例。至于畫葉不用花青與藤黃，潑勾多如花青淡勾多如水以表明反轉之花瓣。又下圖之花將筆先調淡綠，再調紅色。故左下一花瓣墨呈綠色。此點上下二圖之月季俱屬没骨畫。寫花時將筆調紅色作成花照待它乾後，再以白粉點墨如教筆。

Painting 18. Pink Roses. The petals in this Mo Ku painting were made with pink[when the paint was thoroughly dry, the light and dark accents were added in white and red.

Painting 19. Rose. Here the flower was painted with a brush dipped first in light green, then in red. The colors blended on the paper and ended in mostly green on the lower petal. Blue and yellow were combined for the leaves, with more blue used for the darker leaves. The lighter hues were achieved by adding more water to the pigments. The young, tender leaves were painted with a touch of red and brown.

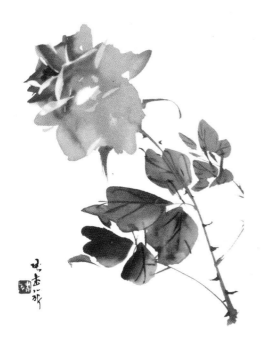

紫，此係自怡色類，用力應均勻，粗細宜相同。全花可用淡墨鉤，葉與幹則用濃墨。此月季係鉤勒法。可用筆毛尖而不全部化開者，以狼毫為佳蓋枝挺硬。鉤勒時，筆須握

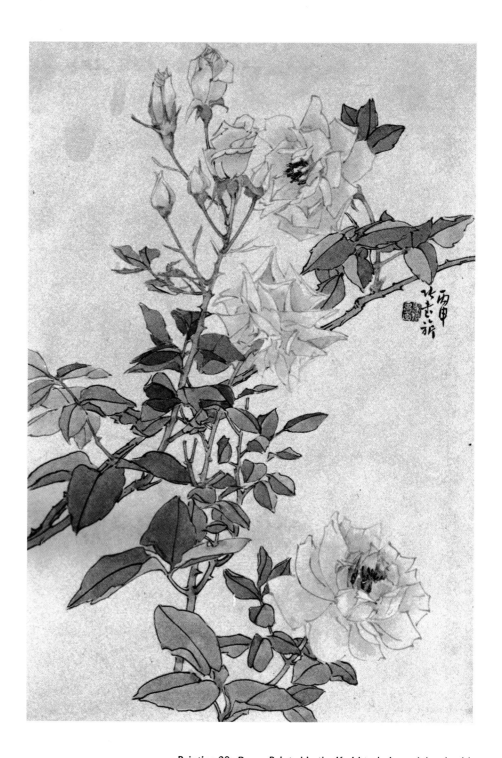

Painting 20. Roses. Painted in the Ke Li technique. A brush with a stiff point was held firmly, and the same pressure on finger movements was applied from beginning to end. Light ink was used for the flowers and darker ink for the leaves and stems.

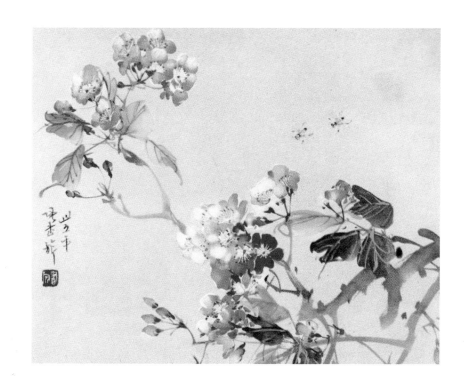

故不如没骨之雅也。

必須適當不能更改,拘勒畫可先作稿本任意更改待確定後印依稿描畫之

上下二圖俱為没骨畫没骨雖不若拘勒之費時祟較易雜畫蓋每一筆觸

Paintings 21 and 22. Crabapple Blossoms; Grapes and Bluebird.
Two paintings in the Mo Ku technique.

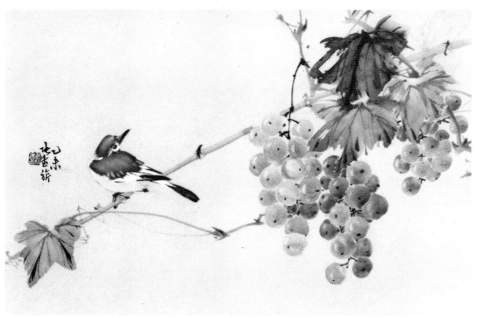

右圖之牡丹屬沒骨法稍寫意畫.左圖屬鈎勒法稍工筆畫.紫花用淡墨鈎出暗部則用較濃墨.幹亦由淺待鈎路乾後再着本種之色.

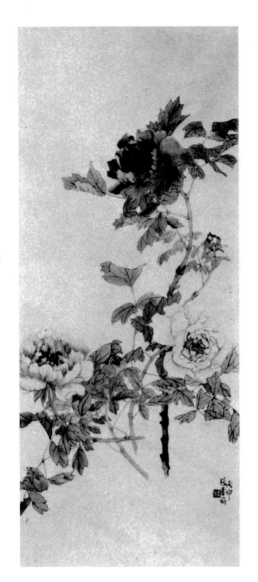

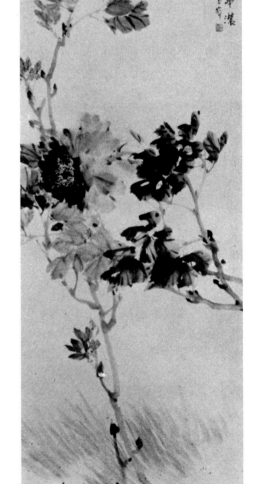

Paintings 23 and 24. Peonies. The flower on the right was done in the Mo Ku and Hsieh-i style, and the one on the left in the Ke Le and Kung Pi technique.

18

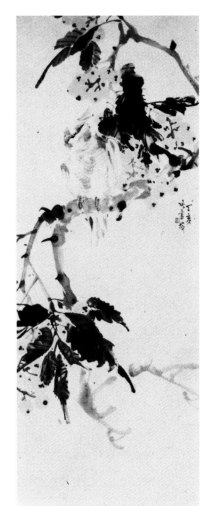

右側（縦書き）：

稱白描畫，係拘勒之一種。

拘好皮黑用淡墨水漂之以今出陰陽向背，不如顏色。

此拘勒之水儒，用淡墨拘花，用濃墨拘葉，及点花心。

左側（縦書き）：

西批把則寫沒骨，左者一切俱係拘勒。

二者俱係鸚鵡屬題材，惟右者係寫意畫，左者屬工筆畫，右者之鸚鵡為拘勒。

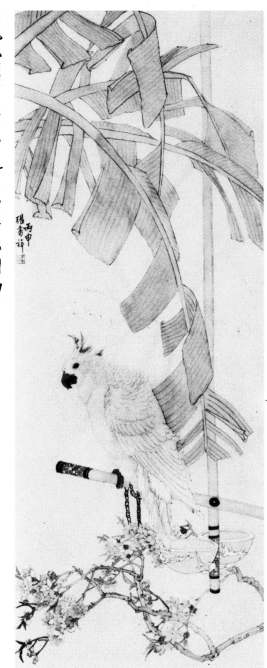

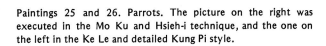

Paintings 25 and 26. Parrots. The picture on the right was executed in the Mo Ku and Hsieh-i technique, and the one on the left in the Ke Le and detailed Kung Pi style.

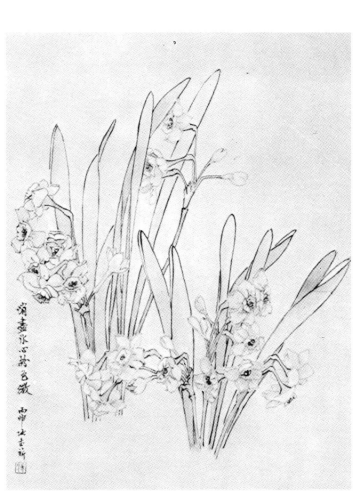

Painting 27. Chinese Lilies. A monochromatic study, painted in the Ke Le method. The outlines of the flowers were drawn in light ink, the centers in dark ink, as were the outline of the leaves. Next, lighter ink was brushed on to fill the enclosed areas of the leaves and petals. The entire painting was done in shades of gray from light to dark.

故下圖助用細綠組織而成較為工整，唯用剛勁之綠條，仍不露柔弱之態。

上下二圖所用之筆觸不同，呈現象顯異，上圖係用大筆粗線任意揮罩，氣勢柔柔。

Painting 28 and 29. Mountains; Babbling Brook. Two paintings illustrating different kinds of strokes. The one above, painted with the free-brush technique, has spontaneity and strength; the one below, executed slowly and meticulously, is less spontaneous, yet shows virility of line.

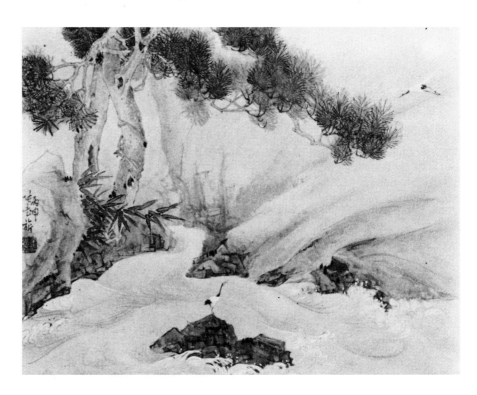

筆觸（即線條）

THE IMPORTANCE OF LINE

中國畫對於線條極關重要，拘勒畫固純屬線條之組織，即没骨畫亦由短線或粗線配合而成。古代作人物之衣褶有十八種不同之描法，如流水行雲，丁頭鼠尾等等，所謂人物十八描。而作山水，有所謂斧劈皴，麻披皴、亂柴皴等等，俱係運用粗細剛柔各種之線條，而表現不同之現象，由此可知線條之重要爲何如。唯于今有一問題，即有時顧慮物形，對于線條不能任意揮寫，因之物形雖似，而線條卻失自然。有時不顧形態如何，任意揮寫，結果形態雖不相似，而線條本身具有美之價值。然則注重形態耶？抑注重線條耶？答曰，若能不失形態，且線條本身亦覺自然，二者兼備則爲上乘，否則與其顧慮形態，無寧注意線條。

A line or brush stroke may be long and thin or short and wide; even a dot may be considered a short line. Lines, either straight or curving, reproduce the shapes of all of the objects an artist wishes to paint. His skill is judged largely by the combination of suppleness and firmness that is indicated by his brush strokes. A painting of merit shows brushwork which has softness and harmony and at the same time gives the appearance of virility. Strokes which appear delicate may, paradoxically, exhibit great strength. More than any other element, the brush stroke embodies the technique of Chinese art. (*See painting* 29.)

As mentioned earlier, Ke Le paintings represent pure outline drawing, and are therefore fundamentally linear in character. They depend entirely upon the beauty of the stroke to attain the rhythm for which they are noted. Line brings out the contour to produce the illusion of perfect modeling. The thickness or thinness of the line depends on the pressure of the hand. In his free and eloquent brush strokes the artist may exert all his strength, starting from the shoulder and coursing down through his fingers to the tip of his brush. He must have a sure hand, for every stroke shows on the porous paper or silk, and there is no way of cirrecting an error. The student should aim for form, balance, and strength of stroke. His work will attain sweep and rhythm as he technique of changing the pressure on his brush, so that the ink may spread in broad masses or in delicately shaded lines without interrupting their flow.

Mo Ku painting, though it does not employ outline as the starting point of a composition, is nevertheless made up of narrow or wide lines of varying character. Here the firmness of the brush stroke plays an equally im-portant part. (*See paintings* 28, 31.) A fine, thin line, a jagged line, a thick, heavy line, a soft, light line—each produces an entirely different effect. The whole mood of the painting is set by the quality of its lines. (*See paintings* 30, 32, 33.)

One may get an idea of the importance of line in Chinese painting by citing the following example. If an artist should paint a flower with meticulous care, he would reproduce its form perfectly but would probably not be placing emphasis on beauty of stroke. The result might be an exact copy, but would possess little feeling of growth and originality; it would be stiff and lacking in grace. Conversely, an artist might have only the quality of stroke in his mind, and pay little attention to the structure of his subject; the beauty of his strokes would be there, but the likeness would be inadequate. If he must err in one direction or the other, perhaps it is better for the artist to concentrate on beautiful strokes which are in themselves elegant, fluid, pleasing to the eye, rather than to paint a picture which is accurate and dull. (*See paintings* 34, 35.) But his ideal purpose should be to produce a combination of animation and faithfulness to physical detail, a painting whose beautiful strokes combine to present a good likeness of the subject. Such strokes provide the flowing rhythm and suspended motion that suggest the movement and continuity of living things. Brush strokes light and dark, wet and dry, heavy and thin, curved and straight, all with varied spacing—these the artist may achieve through long practice until his work shows power, flexibility, gracefulness, and balance.

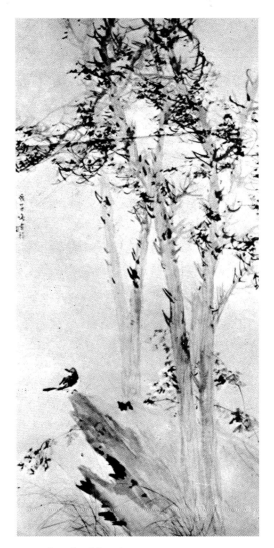

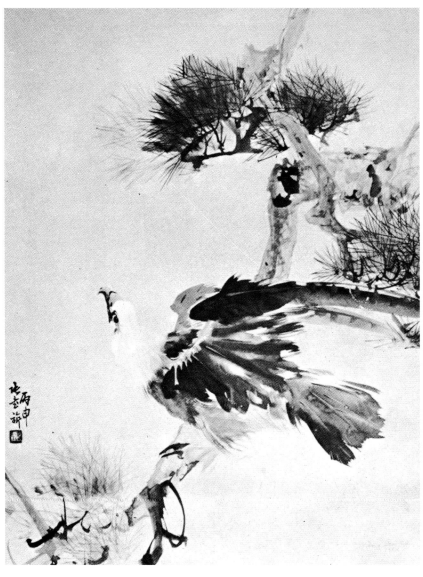

所作風樹純用粗細線條細密而成用筆須
流利活潑老幹固可挺直而細枝必須飄
擺以表風勢至于小菊細草尤須呈動態
由右向左沿循與樹枝不相衝突

此松應取其雄健豪放之勢凡作畫
束動筆前應先考慮題材應用何
種筆觸待胸中成竹勇往直前以獨弓
巨弩礪機躍發旺李開先所語勁筆
是也

Painting 30. Windblown Trees. The windblown effect was obtained by the use of thin and heavy lines. The strokes were executed freely and quickly, giving a lifelike quality to the subject. The trunks, not affected by the blowing of the wind, were painted in their natural growing position. In keeping with the direction of the wind the grass and small chrysanthemums lean the same as the branches and leaves.

Painting 31. Eagle. A study showing great virility of stroke. To achieve this, the artist must have decided not only on the subject but on the exact type of strokes to be employed. He can then paint with confidence and courage. Both these qualities are discernible in strokes of the painting.

Paintings 32 and 33. Old Pine; Orchids. A study in contrasts. In the first painting heavy dark colors and broken lines depict the age and strength of an ancient cypress tree. In the painting of the two orchids, light strokes and soft colors were used to show two orchids, light strokes and soft colors were used to show tenderness and delicacy.

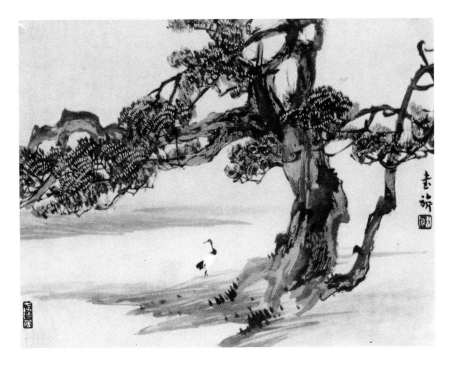

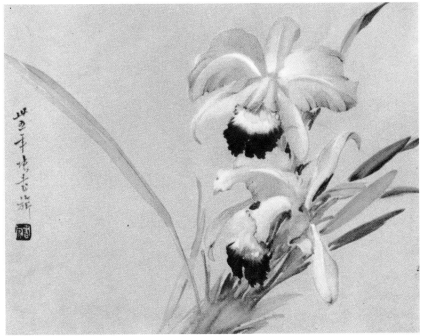

何種筆調，

渲曲之筆調才能顯出婊嫩羨麗之姿態。學者應懂體物之概，詳夜何種題材應探

工圖之老樹係用古撲沉着之筆調才能顯出蒼莘古老之氣象。下圖蘭花則用秀俊

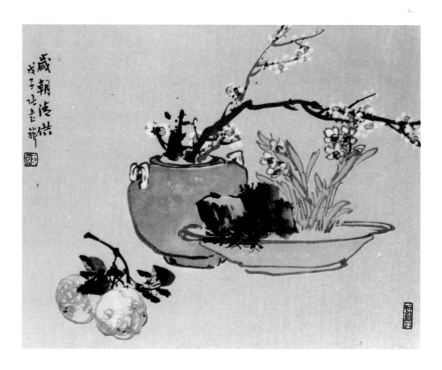

與尾注意于形態並注意于線條。

而線條本身尖却自由。下圖則注意揮寫，瓶盆形態由不及上圖之精，而線條流利得多。

上下二圖俱屬瓶盆景，上圖因顧慮瓶盆之形態，對于線條不能任意揮寫，故形態由正確，

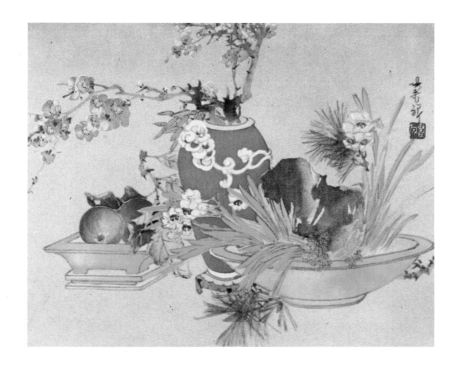

Paintings 34 and 35. "New Year Greetings"; Floral Arrangements. The first gives the actual appearance of the containers and their contents by means of meticulously executed strokes. In the second painting the objects, which are not as carefully painted, produce a more animated effect with greater originality.

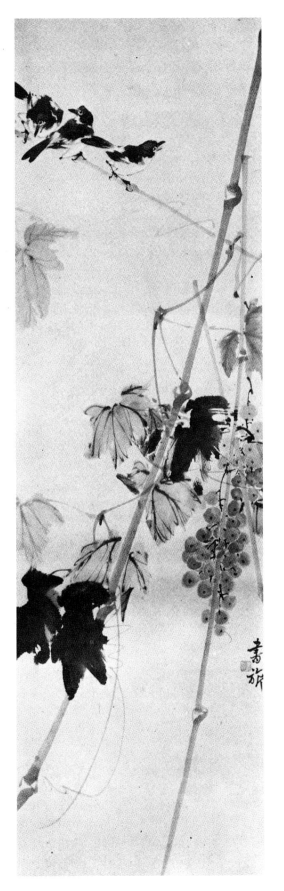

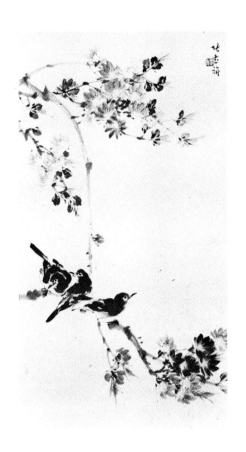

此圖係取右面下圖之葡萄而配以右面上圖之小鳥擇畫中我所愛好者合而爲一能以

蟲鳥臨摹而已懂得佈局之道可以變化堂竅不受臨本之拘束矣

Paintings 36, 37, and 38. Grapes, Birds, and Blossoms. These three pictures show how subject matter can be combined. The birds in the painting above and the grapes in the painting below are brought together and rearranged in the composition at left.

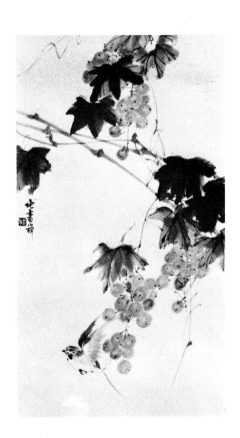

臨摹

COPYING AS A METHOD OF LEARNING

臨摹二字與寫生對立。寫生係寫宇宙間之物象，非臨他人作品；臨摹則將他人所作模寫之。初學者對于作畫未有門徑，不知如何著手，故將名人作品摹臨之，俾能領悟種種畫法上之要則。臨摹之道可分三種：(一)完全臨摹。即無論章法，題材、色彩等等，——依照他人作品摹寫之，不改加變。(二)部分臨摹。照他人作品摹其部分，而捨其餘，或取數畫之長，而配合為一。例如取此畫之鳥而配以他畫之花木，或摹甲作之木移置于乙作之山石上，而另成一畫。(三)畫法臨摹。以上(一)(二)兩種臨摹，俱有跡象之可睹，至於畫法臨摹則否。例如他人寫梅花，我摹其章法，而改作桃李，此章法之臨摹也。他人以焦墨寫花木，我則摹其用焦墨方法而作山水，此用墨之臨摹也。他人用側筆寫山水，我摹其側筆之法，以作樹木，此用筆之臨摹也。記余昔年執教時，見某生作一大幅荷葉，翠綠淋漓，其中僅有含苞將放之紅花一朵，殊有生趣。余即取其意作一綠芭蕉，葉上棲一紅蜻蜓。次日將該畫示諸生，並對某生曰，我此畫係臨汝之作品，某生茫然不解其故。我曰，汝非作一大幅荷葉，而用一點紅花者耶？我此作即取汝之彩色，而改作綠芭蕉與紅蜻蜓者，由此汝等可悟臨摹之道矣。

From ancient times to the present, Chinese artists have copied old masterpieces as a way of learning techniques. In following this procedure the student should not merely be making mechanical imitations; he should be striving to understand the skills of the painters of these older works of art, and his efforts should produce re-creations of the originals, painted with thought and intelligence. After learning how the great masters have worked, the young artist must gain complete mastery of the brush before it will respond to the commands of his mind. He may then consider himself adequately equipped to create independently.

There are three ways by which a student can copy another artist's work while learning. He may reproduce the painting in entirety—strokes, composition, colors; this may be useful to the beginner. Or he might copy only a portion of the painting, after dividing the composition into its component parts. With added experience he may find it desirable to select parts of more than one painting, and combine them into a new and complete study. (*See paintings* 36, 37, 38, 39, 40, 41.) This step will help the beginner to learn more about composition. If at this stage of his development a young artist

particularly admires the strokes or colors used in the painting of another, he may profitably copy them in his own work. As an example, let us suppose that trees are an important part of a finished painting, and that the strokes used in painting them are of interest to the amateur. By way of experimentation he may adapt these strokes to his painting of flowers, with highly satisfactory results. Or it may be a beautiful and unusual combination of colors which attracts his attention, and which he may introduce into his own studies to advantage.

This approach to the appreciation of the paintings of others may be helpful to the experienced artist as well as to the beginner. One of my students once submitted to me a study he had just finished. In it he had used several shades of green to paint large lotus leaves, and then for color contrast he had added a red bud of the lotus blossom. The color combination was so striking that I at once adapted it in a painting of my own showing banana trees. The lovely fringed leaves were painted in shades of green, and for contrast I added a red dragonfly. Next day I showed my painting to the student who had painted the lotus, saying, "You see, I have learned from you too. I have adapted your technique." The boy answered, "Why no, master, I have never painted banana leaves with a dragonfly." Whereupon I explained that I had not copied his composition, but had only borrowed his idea of color combination.

In actual fact an artist sees new subjects to paint in every museum or gallery he visits. The techniques, colors, themes used by others are constantly suggesting procedures that can be adapted to his own use. If he is also constnatly suggesting procedures that can be adapted to his own use. If he is also constantly studying nature with a discerning eye, and storing what he sees in his mind, he will be able to transform this wealth of material, together with his innermost feeling, into a painting filled with rhythm, spontaneity, and living beauty. The Chinese have this to say about an artist: "He must have read ten thousand volumes and he must have traveled ten thousand miles before he is capable of interpreting and expressing his own feeling." In discussing the background of an artist I have frequently drawn upon this analogy: the silkworm feeds upon mulberry leaves, and after due process of digestion changes this material into silk; in similar fashion, the artist calls from memory material absorbed through keen study of the world about him, and transposes his knowledge into the desired end result, a dynamic painting.

A word of caution regarding copying may be added for the student. In the end, every artist must find his own means of expression, however closely his style may follow that of a master or of a school of art. If copying

and imitation are continued beyond his days of learning, he may become so dependent upon this crutch that his creative ability will slowly become devitalized. He must ever bear in mind that while technique may be learned from his ancestors, inspiration comes directly from nature. Other artists' paintings may inspire the serious student, and stimulate his imagination by revealing new methods. It may not be difficult to reproduce the art form of another's work, but to capture and transfer the spirit is another matter.

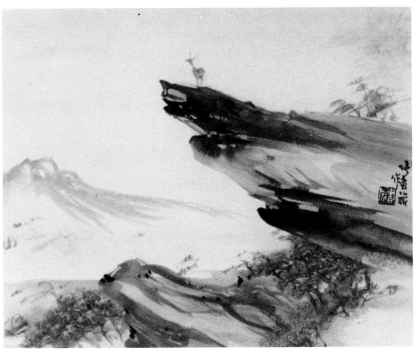

Painting 41. Summer. A third variation shows a change in the position of the rock and the figures. In addition, a waterfall takes the place of the background mountains and sunset.

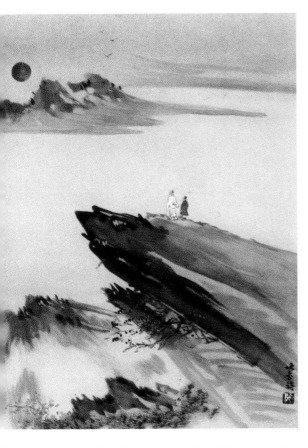

Paintings 39 and 40. "Inspiration Point"; Sunset. Another illustration of "borrowing." At first glance the picture at the left appears to be quite different from the one above. However, closer examination shows that the rocks in the foreground are similar. The setting sun over distant mountains, and the figures and other foreground details, have been added to provide a new composition.

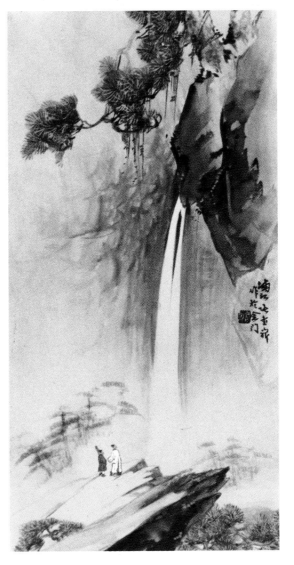

下圖之山水，即採取上圖之岩石，

如人物，分別以遠景之夕陽襯

視之似另是新意實助由上

圖脫胎而成者此。

臨本待至相當技能應自行用心取他人之一部而另構新圖為將來自行創造之基礎。

是舉一二成例耳學者由此以悟為何臨摹古人，在初學作畫時未足門徑固不能不一像

此圖又乃由39及40兩圖畧加変化而成夕陽改為飛瀑而人物則由右轉移為左另成一畫此不過

27

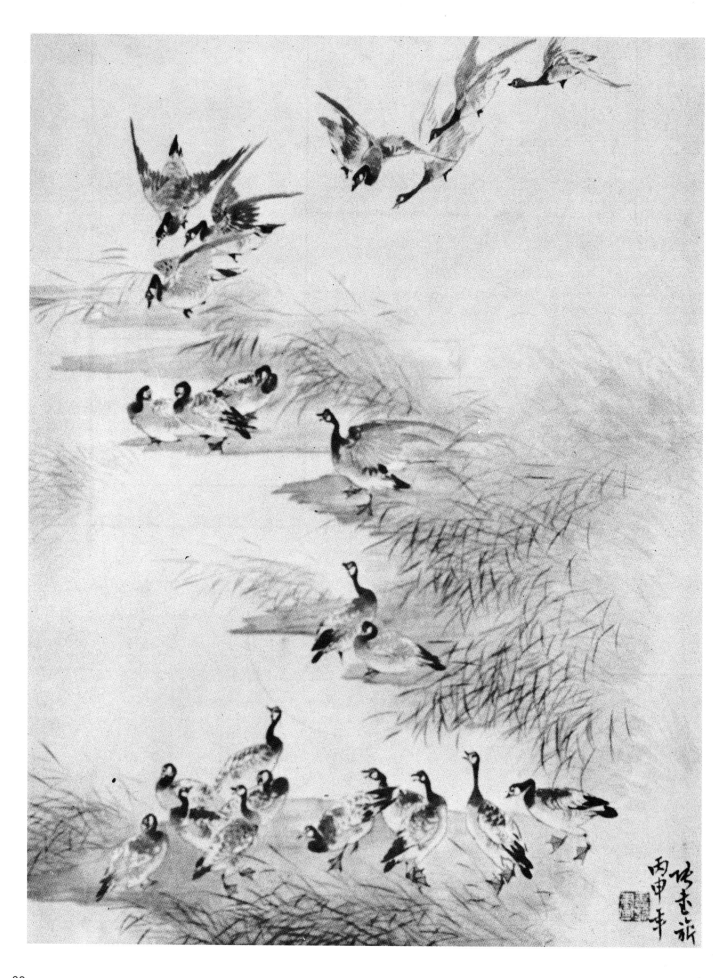

此數畫皆由の求圖中採取而成由此可明構圖之道全在學者慧心目用耳。

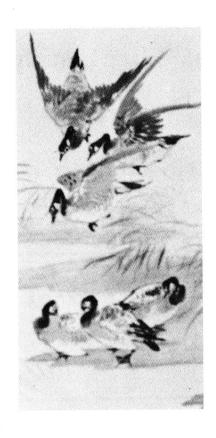

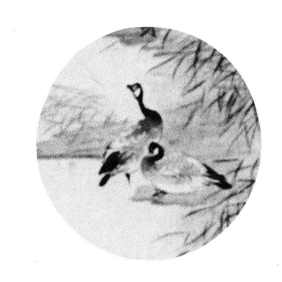

Paintings 42, 43, 44, 45, and 46. Geese. Components of the painting on the facing page are reproduced here as separate studies. These units may remain as complete pictures in themselves or they may be recombined to produce new compositions.

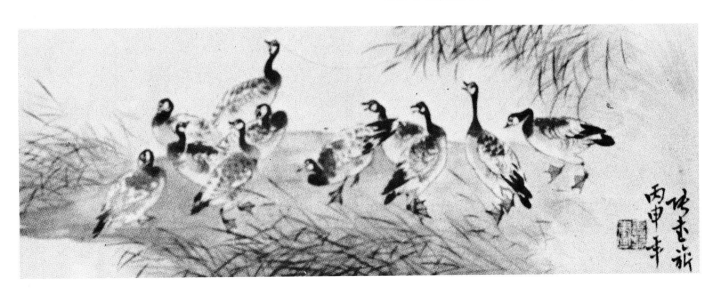

29

乱菊章炎。

以一枝言若枝莖逢葉而除去部分總之自然問照三色三濱由自己選擇及安排否則雜

佈滿以不高低相勻在一叢之花內取若二三枝或三の枝思選定之意趣者而捨定源印

此六圖俱係同樣小菊之題材嘗論繪畫或按排盆景均須疏密錯然宜微不能全希

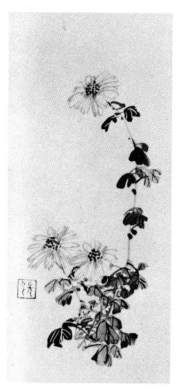
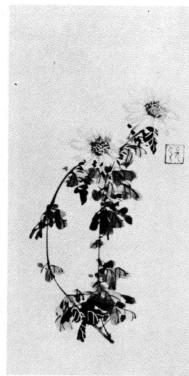
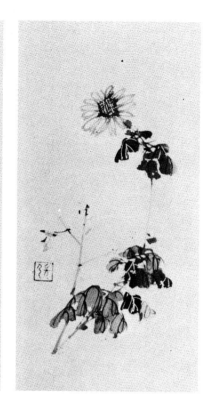

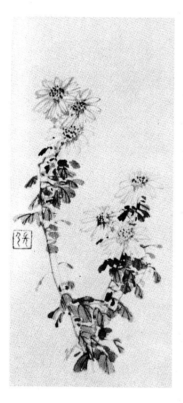
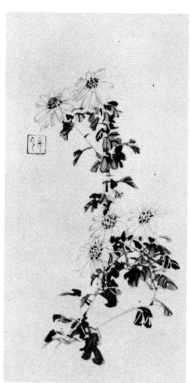
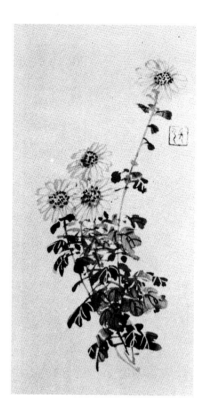

Painting 47. Chrysanthemums. Six pictures illustrate the importance of spacing and the development of loose and heavy masses. These principles are used in Chinese flower arrangement as well as in painting; the artist can rearrange branches and clusters of flowers to produce just the effect he desires.

章法

COMPOSITION

章法即佈局，亦稱構圖，繪畫上極關緊要。章
法猶人之姿態，姿態不佳，雖眉目足取，亦損美
觀。章法變化無窮，要點有三：㈠須有疏密，疏
處力求其疏，密處務求其密。古人云，密不透風
，疏可容馬，此實佈局最要之法則。㈡不宜勻稱，
作二樹不能高下一樣，作二石忌大小相同，必須
錯落有致，不使呆板，如人有二臂，固屬對稱，
然動作時不能同樣姿態。㈢選擇得宜，萬重之山
不俱佳，千里之水不俱秀，一叢之花不俱美，數丈
之木不俱雅。同是一石，左觀如此，右觀又如彼
。同是一鳥，置于此處為宜，置于彼處則否。吾
人須以銳利眼光詳察繁雜之事物，取其精華，捨
其糟粕，配合于適宜之處。

Composition involves bringing together the various elements of a subject and placing them in a pleasing arrangement; it is the structure or framework upon which a work of art is built. Harmonious relationships of the component parts create the desired result, a sense of unity. There must be balance and harmony in a composition, but it must not be static. In Chinese art the painter strives for perfect rhythm in composition. His picture should have a grouping of objects in harmony so that a viewer could take out almost any part of it and still see a well balanced composition in what remains. (*See paintings* 42, 43, 44, 45, 46.)

The artist should have in mind all the important features and characteristics of his subject before he starts to work. He may then proceed to compose his picture with due regard for spacing, symmetry, and selection. Spacing may be used to emphasize the values and proportions of his subject. Unfilled portions of a picture do not necessarily represent merely empty space, for the imagination of the observer supplies the details as his thoughts are drawn from the concrete to the non-visible. The shapes of spaces may assume an importance scarcely less than the shapes of features to be protrayed, and may be made to play an integral part in composition. Proper spacing will create an inexpressible richness in calm and reposefulness. A painting should have open as well as heavily massed parts, and the open areas must be balanced in strength by the heavy elements. Proper spacing, in the words of a Chinese saying, will be "so solidly grouped that not even the wind can pass, yet so open that a horse may walk through it." (*See paintings* 48, 49, 50, 51, 53, 54, 55, 56, 57, 58.)

The concept of symmetry should not be taken to indicate that there will always be complete equilibrium in the arrangement of a painting. The balance required is not one of absolute symmetry, but involves rather an artistic license of variation. Complete regularity of form and arrangement should usually be avoided. If a painter places two trees in his landscape, one should be made taller than the other. Two rocks of the same size and shape produce a much less interesting effect than those which show irregularity. In fact the principle of irregularity should prevail in the arrangement of subject matter. Subordination of some parts of a subject tends to create rhythm which is mobile and temporal. There must be full recognition of the relations of principal and subordinate parts of a subject if this sound rule of composition is to be successfully applied. (*See paintings* 47, 52.)

A painter need not always reproduce exactly what he sees in a landscape, nor the grouping of all of the objects present. He must learn to select the mountains, the expanses of water, the human figures which are of parimary interest and which are most suitable to the subject of his painting. He must build his picture around the essentials. In acquiring this skill of selectivity there is no substitute for constant observation, practice sketching, studying what other artists have done to produce pleasing results. A sense of values must be developed. A distinguishing contrast of color or form can make some features outstanding in contrast to their surroundings. And it must be borne in mind that "the hand cannot execute what the mind has not experienced."

While it is hard to formulate a set of rules, the following procedure may be recommended to the artist wishing to paint a landscape. At the outset he should study the scene as a whole; he must decide, before he takes up his brushes and colors, which elements are vital and interesting, and be prepared to omit those which are not. If many objects are included, the painting may become cluttered and too "busy." Such "spottiness" involves a violation of the basic principles of composition. In composing his painting, the artist must always be concerned with balance, harmony, and proper spacing. Life and movement must be depicted with a minimum of strokes if his work is to have a dynamic quality. He should paint rapidly and confidently, and yet with restraint.

It was the desire of CHinese artists in early times to express a continuity of life, a spirit of immortality. Nature provided both the subjects and the inspiration. In our later years we must still turn to the world about us if we are to acquire the feeling for design and rhythm that characterizes the work of the old masters.

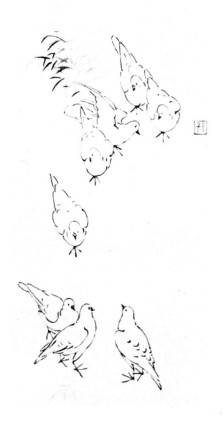

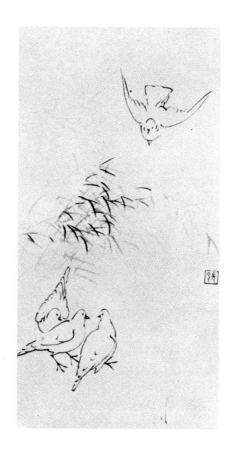

此群鴿示示佈局之道或飛或立姿態不同要在疏密相間高下參差不忌星羅棋佈滿幅堂堂好之地

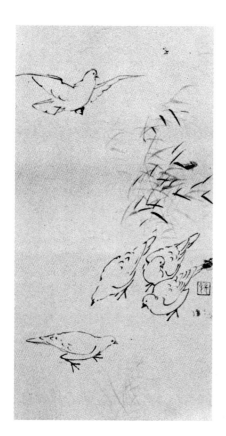

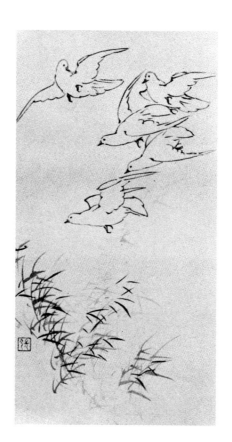

Painting 48. Doves. These four compositions, which
exhibit heavy massing, loose structure, and high and low parts,
represent another lesson on grouping and spacing. Evenness of
height and excess of material are underirable.

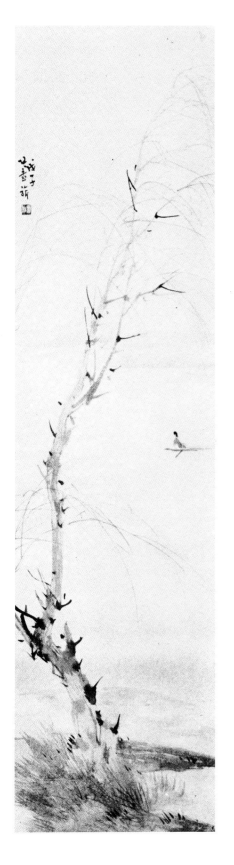

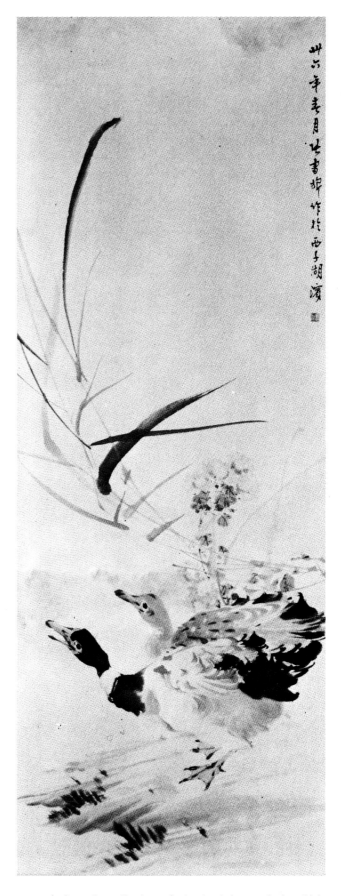

若佈滿必呈飄搖之態。

鴨首附近決不能再作他物否則阻塞覺玲瓏意景左圖細柳絲 空間多呈空白地位，

一畫之章法示不宜全帝佈滿必須呂空白地位此二畫皆于空白寡尋求它意右圖

Paintings 49 and 50. Autumn Willow; Ducks. Here again the importance of spacing is to be noted. In the example on page 62 the grace and beauty of the willow branches could not be seen if there were not empty spaces. In the painting on this page the eye is drawn immediately to the heads of the two ducks, which have clarity and brilliance because of the empty space around them.

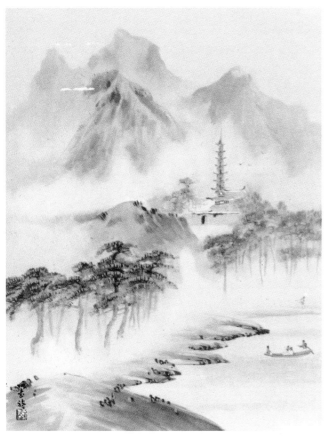

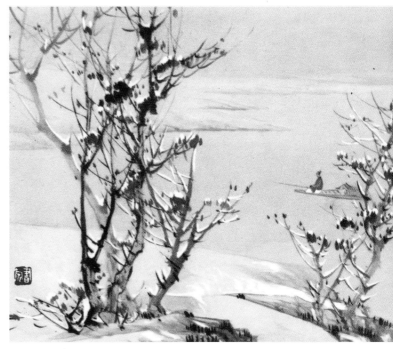

Painting 52. "A Winter Scene." The tree on the left with its trunk and many branches indicates the heavy massed area in this composition. The sky and water serve as empty space which sets off the trees. The small tree on the right indicates the lower level of the hill. This is another example of grouping, spacing, and picturing different levels in a landscape.

此圖應注意于雲霧蓋全惟重岩疊嶂又呈叢林
圓虎若些雲霧則阴塞矣故一畫須呈虛呈實宜
印空白此此畫用雲霧以作空白

Painting 51. "Visit to the Temple." Since this landscape is composed of many subjects, it was necessary to break up the heavy massing of the mountains and trees. Mist was introduced to give a feeling of space between the two groups; otherwise, the mountains would appear top-heavy.

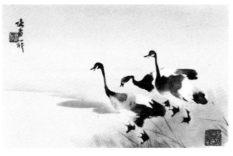

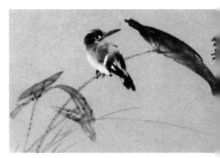

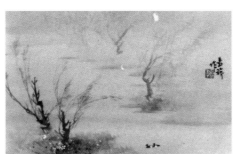

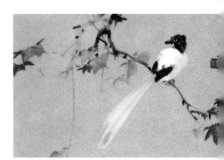

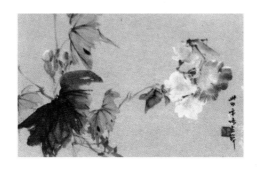

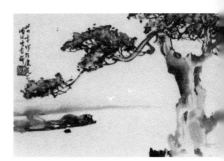

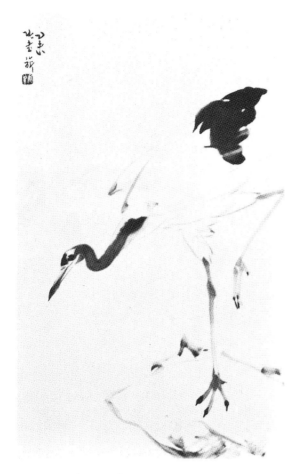

石仿三五成群，錯落星徵，不使互相枝之象，
緊支排筆，左宣九可，而水固妥室，石亦宜，又左右二叢之間，左高

容馬密不透風，一再為學者言之，蓋疏密疏密為佈局疏密之道也。

此圖或工畫下疏，或在多古少，要在為畫具足亦互密古人云密

簡化
SIMPLICITY

國畫之要在乎用筆，用筆之貴貴乎簡潔。李成惜墨如金，言其不多費筆墨也。唐張彥遠曰夫畫特忌形貌采章，歷歷具足，甚謹甚細，而外露巧密，所以不患不了而患于了。清惲南田曰，畫以簡為主，簡之入微，則洗盡塵滓，獨存孤迴。由此可見古人對於筆墨極注意于簡化也，寫畫時應取其有意有趣味之緊要部分，而刪去其無意義趣味者，這就趨于簡化之道了。唯繁易簡難，繁則雖有敗筆，較易隱藏，簡則一點一畫俱須挺秀，稍一不慎，則弱點畢露，故覺難。請無以其難而不敢試。

Stroke has been discussed as an inherent part of Chinese painting in Chapter 6. We may now consider one of the essential features of a stroke, its simplicity. The Chinese consider simplicity to be the epitome of refinement. Li Cheng had this in mind when he said, "Ink is as valuable as gold." He did not use excess ink, or many strokes. He was working for simplicity. Chinese art is subjective and highly symbolical. Overemphasis of its implications would be vulgar. Furthermore, the Chinese method of painting from memory is most effective in eliminating immaterial details. So the absence of ostentation and complexity in line, color, and design has come to be the rule for a successful painting, and accounts for its sincerity and naturalness (*See paintings 59, 60, 65, 66.*)

The free-flowing stroke in a beautiful picture looks almost careless, but in reality is the result of long years of laborious drills and exercises. Great art is always simple, never obscure and confused. To say much with little is its highest aim. When there are many details in a painting, the beauty of strokes and the harmony of colors cannot be seen. The qualities of living beauty and spontaneity in a painting do not come as accidents, but are carefully planned. (*See paintings 61, 62, 63.*)

Keeping simplicity in mind, an artist must exercise great care in executing strokes and in his use of color. A "busy" painting with redundancy of strokes is the work of an amateur. It may not be easy for the young painter to achieve simplicity of stroke and design, but young and old alike should strive for it. The more unpretentious the motif, the better. Proper spacing and restraint in arrangement provide the framework for high expression; an empty area can be made eloquent. (*See paintings 64, 67, 68.*)

To summarize, the artist should aim for sparseness in the number of features used to convey his ideas. The fundamental value of simplicity cannot be overemphasized.

Paintings 59 and (*opposite*) 60. Crane; Lotus and Kingfisher. Two pictures demonstrating simplicity in composition and stroke. To obtain this quality all unrelated or non-essential strokes must first be eliminated. Only those strokes that are absolutely necessary to form each object are left in the paintings. Then, with care, a few embellishments are added in appropriate places.

畫學者應練習之。
二次再減一二，待減筆不減印成簡筆塵滓學簡之法有先畫一物，試減去，此二圖俱用減筆寫成簡之入微助洗盡

Paintings 53, 54, 55, 56, 57, and 58. Birds, Flowers, and Landscapes. Six compositions exemplifying compact arrangement and proper spacing. Note how the heavy structure may be above or below, at right or left in the composition.

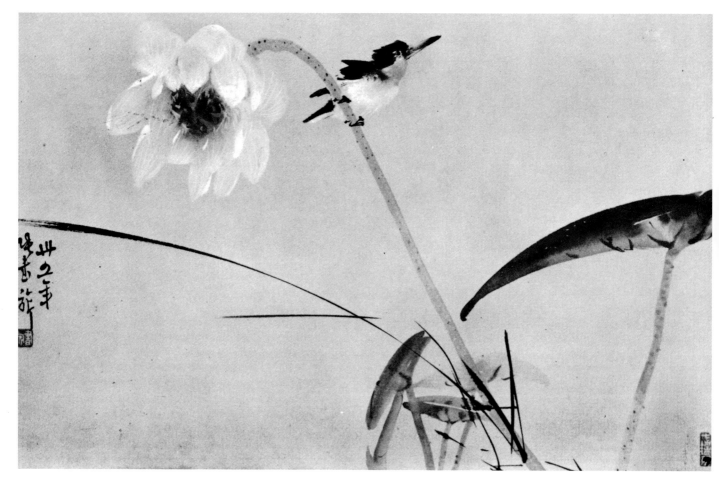

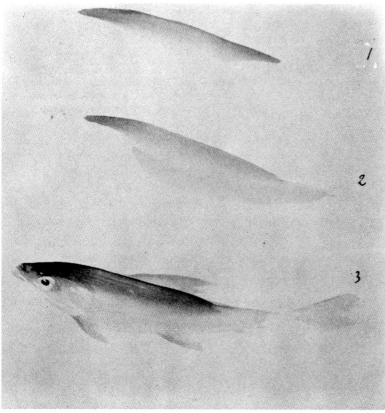

他部份勁而端詳審察不必急。此末乾前二筆合成否則顯出痕迹亦不雅觀至于全成頭尾及翅所應注意者一二兩筆須快捷少于簡筆作小魚。第一筆為魚身第二筆補魚腹末了

Painting 61. Fish. A study plate showing essential strokes in the painting of a fish. The first stroke makes the upper part of the body; the second forms the belly; finally the head, tail, and fins are added. The first and second strokes are executed quickly in order to obtain a watery appearance, and close together so they blend into a single unit instead of appearing as two distinct sections. The other parts of the fish can be painted separately at a more leisurely pace.

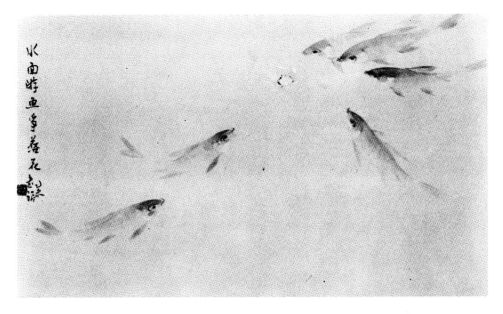

水面特畫魚落花紅謀

侔有以類推矣。
法作成若能寫定一列亦
此群魚亦用上述簡筆之

Painting 62. "Swimming Group." The fish in this picture were painted by the simple method demonstrated above.

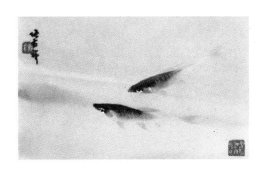

Painting 63. "Swimming Pair." A third example of fish painting done in the same manner. After the two fish were outlined and the colors had dried, a wide brush was used to paint the surrounding water.

少再行畫水
待魚身全乾
簡筆法作成
此二小魚亦用

別業他物以示簡單之意。
此幅之魚並非用一二簡筆寫成梁陳魚外

Painting 64. Catfish. The shape of these fish required a slightly different technique. With a very wet brush several light strokes were blended together on the paper. Darker areas were added while the first strokes were still wet. The simplicity of the composition resembles the other examples shown on these pages.

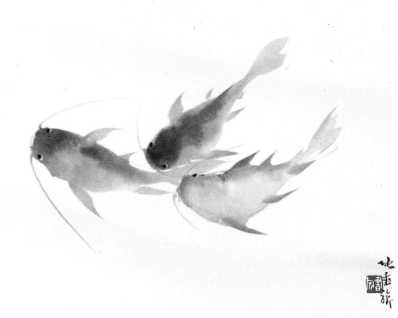

及點眼刻成小鳥矣，頭胸背三筆而用淡墨，寫體嘴眼翼尾而用濃墨。

簡筆作小鳥法，一作頭，二加胸，三補背，待頭胸背完成，已具鳥之雛形矣，再加嘴眼翼尾

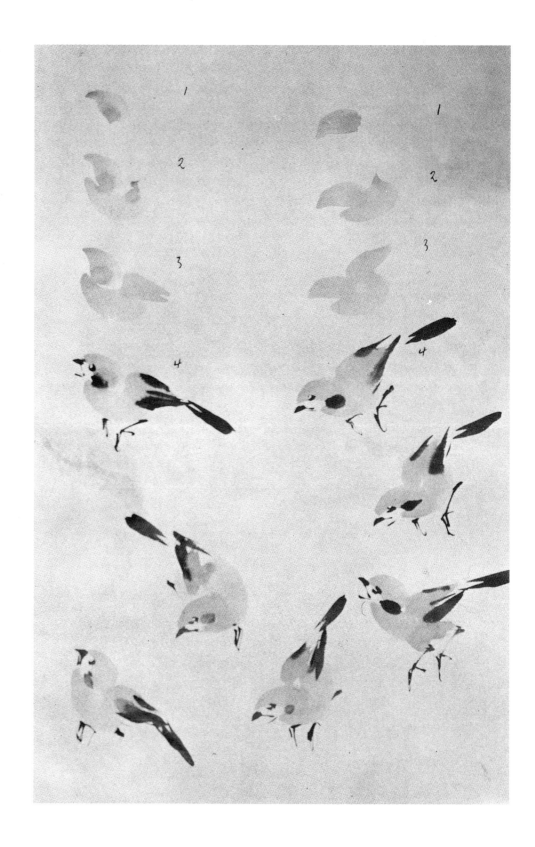

Painting 65. Brids. THis study plate demonstrates the easiest way to paint a small bird. The first stroke makes the head, the second forms the breast, and the third shapes the back. These three parts produce the shape of an egg, which comprises the body of the bird. Then the beak, eye, wing, tail, and feet are added. Light color was used for the first group of strokes and dark color for the details.

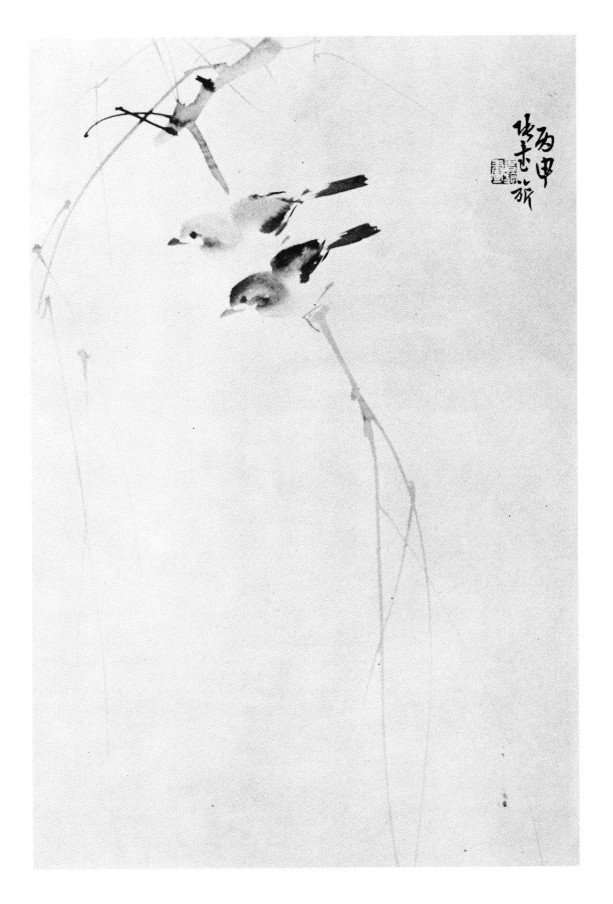

此用前述簡筆作小鳥法所寫成之二鳥，再補疏柳出看墨韻多，而意趣自豐。

Painting 66. Birds on a Willow Branch. Painted in the same manner as shown on the opposite page.

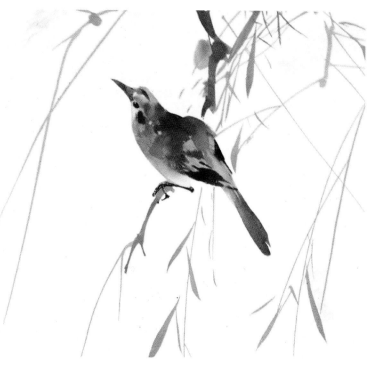

廿三年 此書張作於金門

Painting 67. "Waiting." To keep the bird as the center of interest here, just a few willow branches and leaves were added to produce a simple background in the same tones of color.

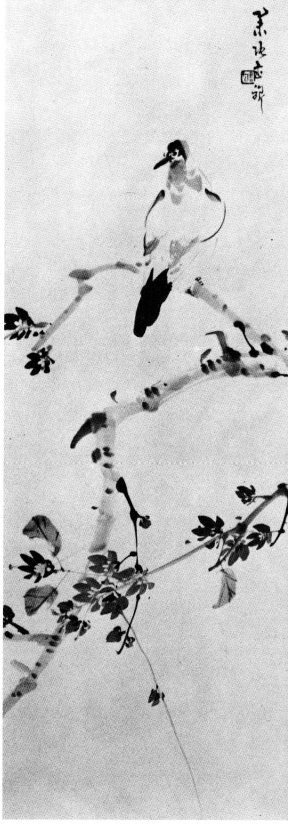

此乃房簡筆畫也若柳葉太多則與鳥身混雜不能如此陰断矣

此用減筆寫鴿及蠟梅如筆須另意趣尤宜梅枝夾渲

揆秀應求緣條本身乃夏之價值不僅湊成花枝而已

Painting 68. Dove. The bird is perched on a branch of quince with blossoms and leaves. The design employs contrasting bold and soft strokes and colors.

40

渲染
BACKGROUNDS

　　吾國之畫多不用渲染，非不欲用，蓋宣紙不宜
于渲染也。察唐宋之畫多用背景，即多作渲染，
蓋所作多係絹本，可以渲染也。如雲如水，在宣
紙上只好用線條表現之。吾輩所用材料若可以渲
染，則亦何必捨易就輕？渲染之筆可用排筆。當
渲染時須勻稱，不可露筆痕。

Background work may be effectively employed to
induce perspective. During the T'ang and Sung dynasties
it was customary for artists to paint in background
scenes to provide spatial depth. At this time silk was
being used, and there was no difficulty in executing
strokes to delineate clouds, mountains, and streams. But
after the invention of paper and its use by artists, it was
impossible to continue the use of backgrounds, for the
paper was an absorbent type not suited to line painting.
So in this period abstract design was used to depict
distant features. Eventually a non-absorbent paper was
produced, and from that time on the artist could paint
anything he desired.

For background washes, select a wide brush and
apply the pigments faintly, with overlapping strokes so
as to leave no lines of demarcation. This smooth and
even background should be set aside to dry before the
foreground features are painted in. (*See paintings* 69, 70,
71, 72, 73, 74.)

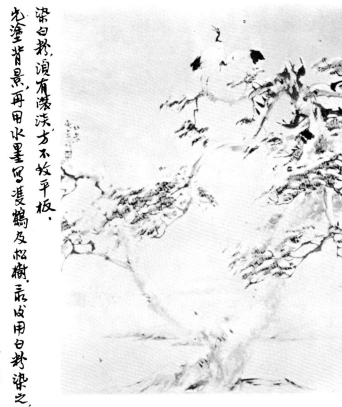

Painting 70. Snow Pine. Here again the background was painted
in light blue. After this had dried, subtle tones of ink were used
to paint the pine tree and the cranes. Finally white pigment was
applied sparingly on certain parts and more heavily on others to
avoid a stiff appearance.

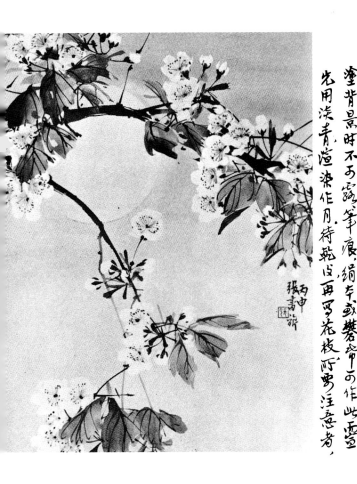

Painting 69. Pear Blossoms. The sky was first painted
in a light blue color. Lines of demarcation were avoided and
carefully overlapped strokes made a smooth, even background.
When the paint was completely dry, the branches and blossoms
were added.

41

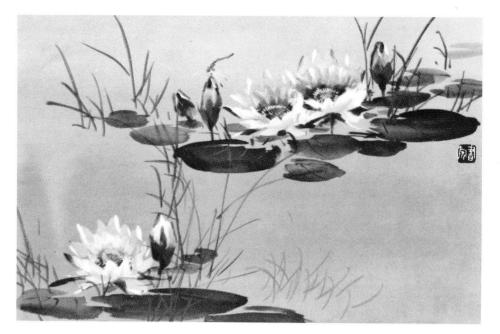

待完全乾後再作睡蓮及其他·
先用綠色（即藤青調合）塗背景·

Painting 71. Water Lilies. Green (made from yellow and blue, with a touch of black) was used for the background. When this was thoroughly dry the water lilies were painted with white and tints of red.

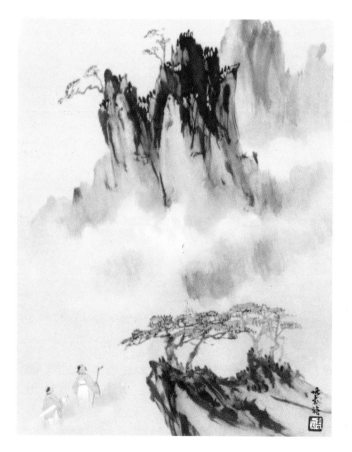

部分乾後再加元色故全幅覺調和·
淡綠淡珠混合之色，滿布塗之，惟須留雲霧之
用墨水寫山石樹木及人物。在未着色以前即用

Painting 72. "Minsty Mountains." In this landscape the mountains and trees were painted first, then light green and touches of brown filled the background, except for the cloud areas. When the painting was dry, the two figures at left were added and various finishing touches were made to accent the outlines and colors.

42

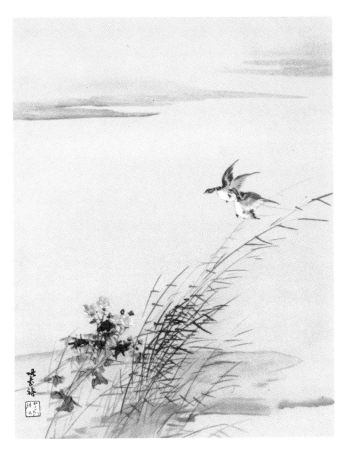

此福背景典睡蓮不同睡蓮係淡綠一種色此幅用
二色,預備二碟,一盛淡綠,一盛淡硃(可畧加黄)
先用淡綠橫塗之,空停一二處,次用淡硃將空除者
塗滿,惟手宜須快搵,二色之間不能呈痕迹,

Painting 73. "Autumn River." Two dishes of pigment were prepared for the background here: one filled with light green, the other with a mixture of brown and yellow. First the green pgiment was washed into the paper with spaces left for the brown-yellow areas. Slightly overlapping strokes allowed the two colors to blend, avoiding a stiff dividing line, which would have been underirable.

Painting 74. "Autumn Birches." For the background wash in this sunset scene, three colors were used—light green, light brown, and light red. The colors were laid on and blended with a wide brush. The foreground was painted later with a pointed brush, using opaque white for the trunks of the trees and for the breast and wing tips of the bird.

此背景則用三色,須用三碟,各碟
分別調以淡綠,淡硃,淡紅,預備好
皮,用排筆以淡綠淡硃先塗工部,次
用淡紅末用淡綠由工至下橫塗之,
取成日暮斜陽之景,

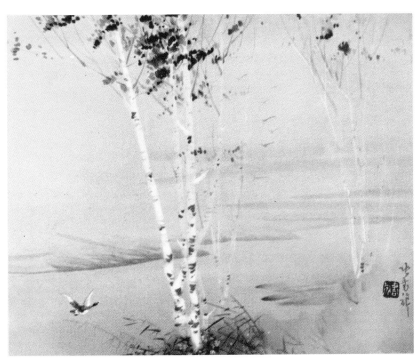

畫花似聞香‧畫鳥若欲語

張書旂的繪畫世界

陳長華

呂鳳子稱讚張書旂的藝術說：「畫花似聞香，畫鳥若欲語。」在中國民初，社會動盪的時代，中西思想交融，出現了許多人才精英，張書旂以花鳥之成就，成爲當時重要的畫家，推崇者不止呂鳳子一人！

任何眞才實學的藝術家，都具備了天賦的眼力和獨有的創造風格。張書旂早年在臨摹過程中滋養自己，學明清的名家遺跡；崇拜潘椒石、朱夢廬、任伯年；甚至拜吳昌碩爲師。爲了學習他的粗獷豪放。直到一九二七年，二十八歲時，才決定了日後窮追不捨的秀俊清美的面貌。

「要變，變則通。學畫應多向古今優秀作品學，集各家所長。像蜂採百花而醸蜜那樣，花是人家的，蜜是自己的，有了自己的東西，才能有獨樹一幟的基礎。」

張書旂的親身體驗，造就了自我藝術，也影響了不少後學人士。

這位繼任伯年、潘椒石之後的花鳥名家，家學淵源。西元一九〇〇年，他在浙江省浦江縣的禮張村出生，原名「張世忠」。張家三代都以教書維生。祖父是清朝貢生，滿腹經綸，可惜與官祿無緣；父親張道行是秀才。叔父張爽甫也是秀才出身，詩書畫三絕，張書旂八歲時經他啓蒙，初試畫筆。

明代大文學家宋濂曾經形容浙江浦江「仙壁爲屛，大江爲帶」，是「天地間秀絕之區」，該縣山明水秀，孕育許多傑出文人。張書旂在此環境下成長，加以嚴格的家庭教育，對他日後的藝術學習不無關係。

據說，他十一歲時畫了一隻翠鳥，長嘴上啣着一條小魚，被他能書能畫的叔父看見了，直誇獎他觀察靈敏。

當時他並得到叔父贈送的「芥子園畫譜」，除了從畫譜中熟悉各種題材的畫法妙訣，在叔父鼓勵下，更熱衷於自然觀察，隨手留下寫生圖。

張書旂在少年「塗鴉」時代即立定志向，希望將來成爲知名的畫家。一九二〇年，他以優異的成績從金華七中畢業，兩年後進入上海美術學校。興趣所向，他已至於廢寢忘食，夜夜挑燈作畫。他事後回憶說，他在上海美術學校求學時，把兩只皮箱拼起來充當畫桌。有時候夜裏作畫，來不及回宿舍，乾脆就睡在畫桌上。當時，志同道合的同學，滿懷熱情地苦耕，連理髮時間都抽不出來。

藝術家當中或有「無師自通」者，但是許多人在學習過程中，都經名家指點而得以開濶視野，精神上也得到鼓舞力量。張書旂一生有幸獲得好幾位師輩的厚愛，像他在金華七中的老師蔣蓬僧、在上海美術學校的老師呂鳳子，以及徐悲鴻等等都是。

張書旂幼年由叔父引導認識藝術；他眞正的啓蒙老師，應該是到金華七中接觸的蔣蓬僧。蔣蓬僧和張書旂是浦江同鄉，和名畫家黃賓虹相交甚深，畫得一手山水畫。他在金華七中擔任張書旂的美術老師，看見張書旂在繪畫方面的成績，極力從旁鼓勵。

呂鳳子是近代有名的畫家和美術教育家。他對於張書旂愛護倍至，曾再三對人說，張書旂是他上海美術學校學生中的佼佼者。他們 師生感情甚爲深厚，抗戰期間，呂鳳子客居重慶，書房即掛著張書旂的一幅「孔雀」。後來，張書旂旅居美國，也對呂師念念不忘，曾滙錢託女兒轉交呂鳳子當作他辦學校的費用，呂鳳子以「一生不受人饋贈」，婉轉推辭。

「書旂之畫，有書旂之面目，非石濤之面目，亦非八大之面目。」呂鳳子對張書旂的讚美言詞，充分流露了老師對於得意弟子的心情；張書旂也將呂鳳子當作他藝術的恩師和知音。一九五七年七月，張書旂胃癌已到了末期，人生旅途將盡，在生命燭光最後搖曳的時候，他以絕筆信感謝師恩，並懇求呂師在他畫集寫序文，無奈呂先生也臥病在床，不能動筆，成爲師生二人的人生遺憾！

張書旂從一九二四年開始擔任教職，曾先後在金華女中、廈門集美學校（後改廈門大學）、南京中央大學等校教授美術，桃李滿天下。在這一段期間，他最重要的機遇是認識徐悲鴻。，

那是一九二九年的事，張書旂在廈門大學教書，以作品多幅參加在福州舉行的「全省美術展覽會」，正巧徐悲鴻應當時福建教育廳廳長黃孟圭邀請，前往福州遊覽，在展覽會場看到張書旂的花鳥畫，大爲讚賞，隨即透過呂鳳子延攬他到南京中央大學任教。

張書旂到南京中大後，教學相長，藝術更得精進。他除了主編「分類國畫入門」—「翎毛集」等書，也在教學方面強調寫實和寫生的法度，要求學生養成基本技巧和理論基礎；課堂上則揮毫示範，從個人生活上飼養的鳥禽動物作爲繪畫對象，學生受益匪淺，徐悲鴻也以深得人才而自豪。

張書旂是十足的藝術家個性。誠實樸素、不重視外在修飾，而天眞浪漫的情懷，強烈的自尊心，都形成了他藝術表現的內在因素。

「拳棋牌簫酒，天下無敵手」這是張書旂的名句。這位藝術家生前經常長衫一襲，衣上到處都是香烟燃破的小洞。他十分怕寒，也在當時藝壇人皆有聞，天未寒，即 身披重裘，不顧他人指點，可見其率性的人生態度。他在健康的時候，以豪飲有名，三杯美酒下肚，談笑風生，在坐賓客無不爲他的談吐傾倒。在朋友當中，張書旂具備濃厚的人情味和同情心，濟弱助貧，慷慨解囊，却不准子女過浮華生活。

張書旂在南京中大教學時，創作數量豐富。一九三〇年和一九三三年，「全國美術展覽」在南京舉行，他參展的作品都有得獎紀錄，並經推介參加在比利時、法國、德國等國舉行的中國畫家聯展，嶄露頭角。一九三五年的十一月三日到七日，他在南京中山北路的華僑招待

所舉行首次個展，兩百多幅作品經訂購一空，從此他受到鑑賞家和收藏界的注目。

徐悲鴻曾經評述說，中國近代繪畫，人物山水不足道，所長者唯有花鳥。他的看法未必代表所有人的看法，然而中國花鳥畫在世界藝術上確實具有獨備的地位，它所顯露的寫實、寫意和神韻生動的特質，非西洋表現的花鳥可以比擬。張書旂的花鳥所以廣受推崇，和他繼承傳統筆墨，進而發展爲個人風格，不無關係。

藝術之成長和自然花木一樣，必須吸收養分，勤加灌漑。張書旂師承的名家甚多，列舉名字，有趙昌、易元吉、黃筌、徐熙、呂紀、陳老蓮、八大、任伯年、潘椒石、朱夢廬、吳昌碩、高劍父諸人；但他不是抱住某一家，亦步亦趨。

「寫生趙昌」崇奉「對景寫生」、「心摹手追」。易元吉畫猿猴獐鹿，必定深入山中觀察其天性。任伯年對象取神，掌握對象瞬間的神態。這些都是張書旂師法的對象。另外，張書旂的畫也受到日本畫的感染。清末康有爲極力主張革新，嶺南派畫家高劍父等人留學日本，吸收在重礬絹素上施以水墨的畫法，張書旂也受影響，他並曾推崇高劍父的作品「氣象萬千，獨出心裁，當今之世，固無人能及其項背。」

張書旂在當時流派林立的上海，能夠採集各家之長，融滙中西之特色，選擇自己認定的寫意和寫實風格，不少藝評家爲他撰文讚揚。然而，不論後世如何評價這位畫家，他的作品清晰地爲他的藝術思想留下註解。今天我們欣賞他留世的許多花鳥，「鳥語花香」，正符合了他生前所追求的「詩是有聲畫，畫是無聲詩」的境界。

張書旂的繪畫造詣，有一半得自他深刻入微的觀察力。他在「翎毛集」中說：「當余作翎毛，每伸素紙，凝神遐想，有時紙上忽現鳥狀，神采奕奕，宛然在目，即握管一揮，每得佳作。」這是來自細心觀察。他除重視眼見之事實，也重畫畫面的意境。一九二三年，他爲南京賑濟會舉辦的一項義賣畫展，畫了一幅「哀鴻遍野」圖，救濟安徽洪水成災待救的百姓，構圖生動感人。蔡元培看了，感動不已，並在上面題字：「瘡痍滿目，何處無之，一經妙筆，耐人尋思。」

張書旂作畫取材相當廣泛，一草一木，都是他的描寫對象；他也採取了許多前人未用的題材，從生活中發掘絕妙雋永的小品，令人玩味不已。

花鳥畫的構圖全靠巧妙安排，眼光短淺或素養不高，往往致使畫面佈局落造於作俗套；張書旂的花鳥構圖，重視主從、疏密、虛實、起結的關係。花鳥全由寫生而來，但非照相似的全盤照收，他以經濟的筆墨，強調主題，淡化配景。他說：「誇張不是標新立異；而是在形神兼備的前提下誇張，使主題更突出，更吸引人。」

張書旂筆下的鳥，有的胸肚特別突出，有時濃化其羽毛，有時以大片的空白，說明對象的對比關係，運作奧妙。所謂「主簡去繁」也是張書旂的繪畫主張。他認爲，筆簡是刪去可有可無的東西，保留最精華的部分，是「高度的概括，一筆著紙，形神兼備。」他拿手的八哥、游魚、小鴨、鴿子等都是以簡筆處理，筆少意繁。

然而，張書旂所重視的「簡筆」並非淡化質感，主要視題材而靈活運用，比方畫枯柳以鋼絲之筆墨；畫老樹則筆筆相加。他善用水墨，已近爐火純青境界，他所指的「濃淡相生」，是表現濃不可凝，淡不可模糊。濃不是孤立的，淡也不是絕對的。他認爲濃淡並無步驟可以依循，全視作畫時的需要，隨機應變。

張書旂畫鳥有獨到的創意。一般人畫鳥，多半由嘴起筆，依次點睛畫頭，加背添翼，畫胸肚和尾足。他爲了抓住鳥的神態，反道而行，先由背部落筆，再寫胸肚、翼尾，最後才畫頭、生嘴、點睛、補足。

張書旂的花鳥畫筆精墨妙，他十分重視色調。他在用粉方面獨具一格，他的畫裏，白粉不可或缺。他不是像多半畫家在個別部位用白粉點綴，而是「計白當黑」，將「白」做爲主色使用。白粉在普通宣紙不易顯露；他以有色的宣紙作畫，如淺藍、淺灰、次青、淡赭等淺色的紙，在這類紙上畫白粉，再調配其他色彩，紙與粉互相輝映，粉因筆致而更顯出雅麗風朵。

徐悲鴻認爲張書旂畫鴿爲「古今第一」；張書旂最有名的一幅鴿畫，是一九三九年所作的「百鴿圖」，這幅畫主要爲視賀美國羅斯福總統三度連任總統而作。爲了畫這張作品，他把米粒撒在地上，觀察群鴿爭食飛翔姿態，並拍成照片，更改草圖達十五次之多。因爲「百鴿圖」，他在一九四一年應美國政府邀請，參加總統就職慶典。

四十二歲的張書旂乘參加羅斯福總統就職之便，在美國各地巡廻展出、講學，同時大量的印刷花鳥畫的複製品和小畫片，買者踴躍，直到現在，還有許多美國家庭保留他的花鳥畫複製品。

當年，張書旂在美國人士面前揮毫，使許多人爲之傾倒，有人形容他是「世界最快速的水彩畫家之一。」但是很少有美國人了解他不到十分鐘的作品，是經過數十年鍛鍊所致。張書旂首次赴美，大約停留了六年，到了一九四八年再次前往新大陸，不料胃疾在身，一九五六年發病送醫，胃癌已蔓延到肝臟，延到一九五七年八月十八日，在舊金山寓所逝世。

張書旂五十七年短暫人生，慘淡經營，克盡了藝術家的本分；他的花鳥畫在中國近代藝壇儘管有人批評，但是贊美者大有人在。他在作品中所表現的圓潤秀逸，對形象的精妙刻畫，用呂鳳子言下的「畫花似聞香，畫鳥若欲語」，形容其獨出機杼、筆簡生動的成就也不爲過啊！

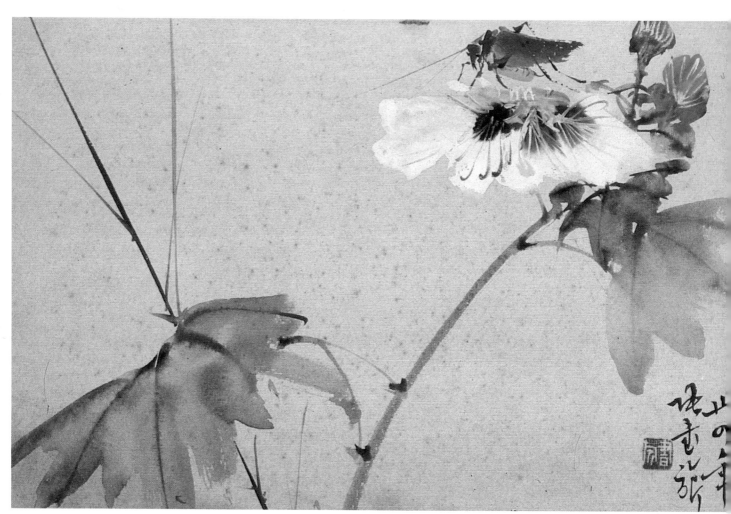

I 芙蓉紡織娘 Pear Flowers and a Cicada

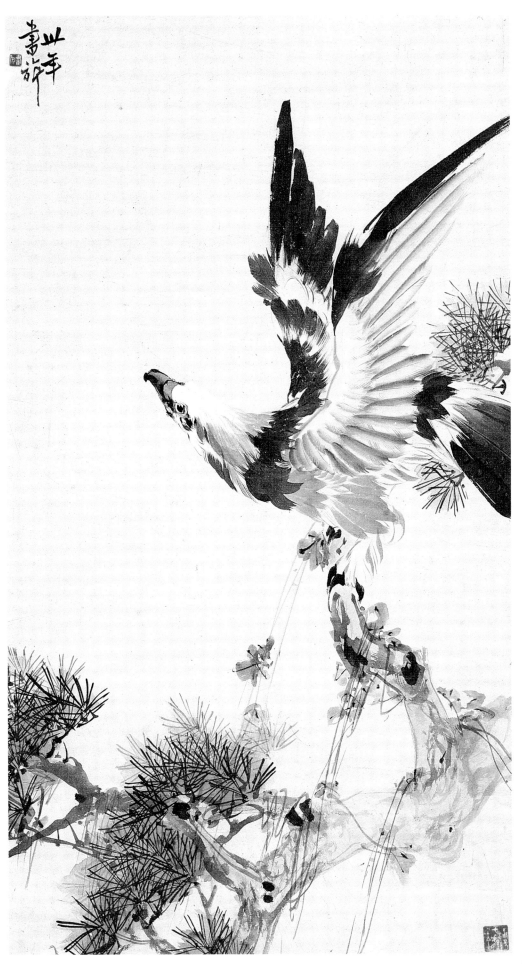

2　待飛
Waiting for a Flight

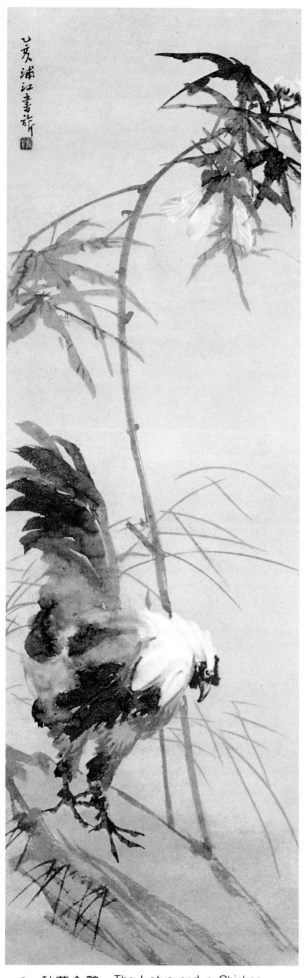

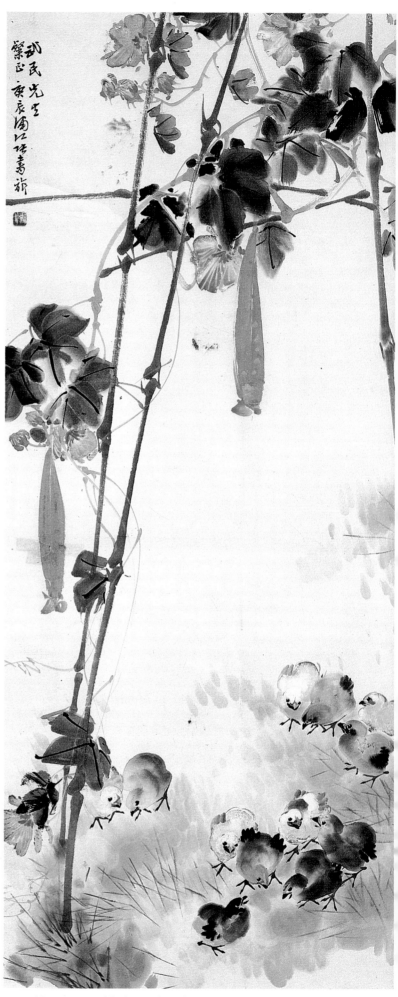

3 秋葵金鷄　The Lotus and a Chicken

4 絲瓜棚下　Under a Loofah Gourd Shed

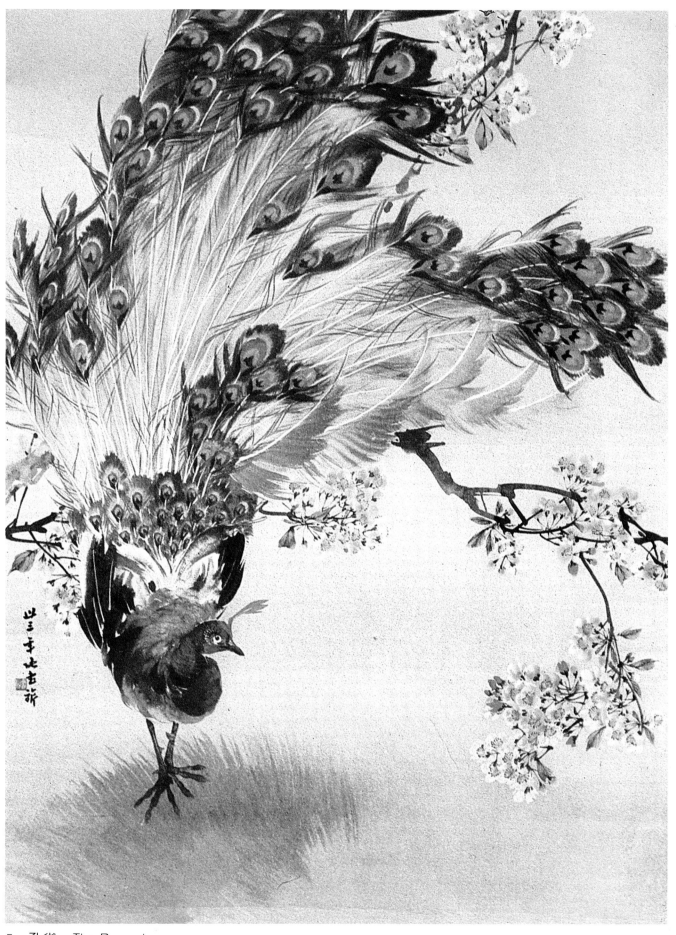

5 孔雀 The Peacock

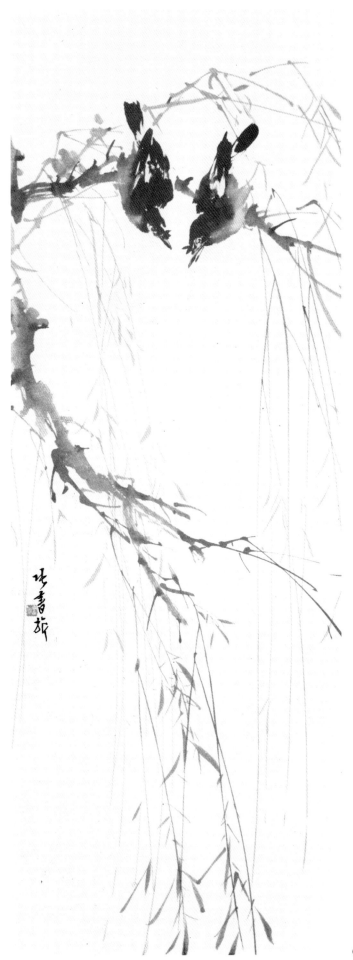

6　柳枝八哥　Willow Branches and Mynahs

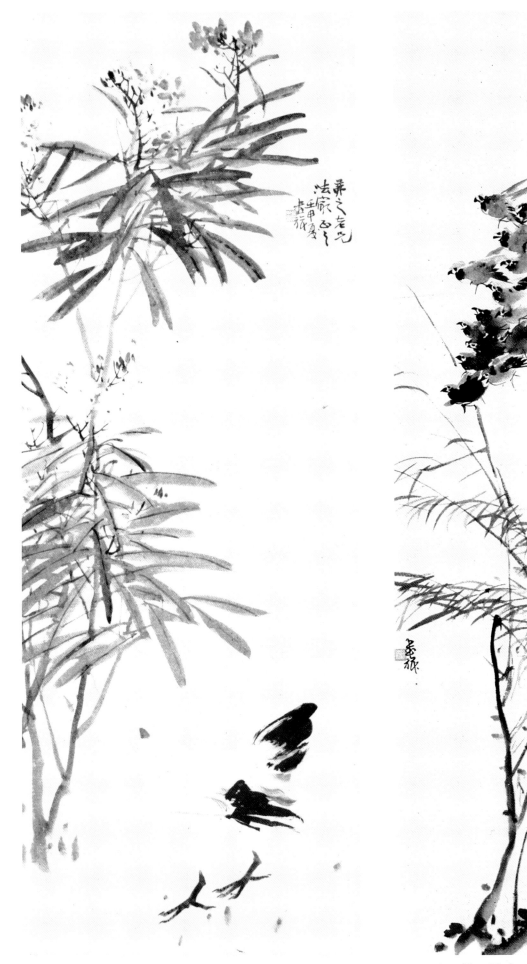

7 夾竹桃母雞 The Sweetscented Oleander and the Chicken　　8 群鳥 The Birds　　51

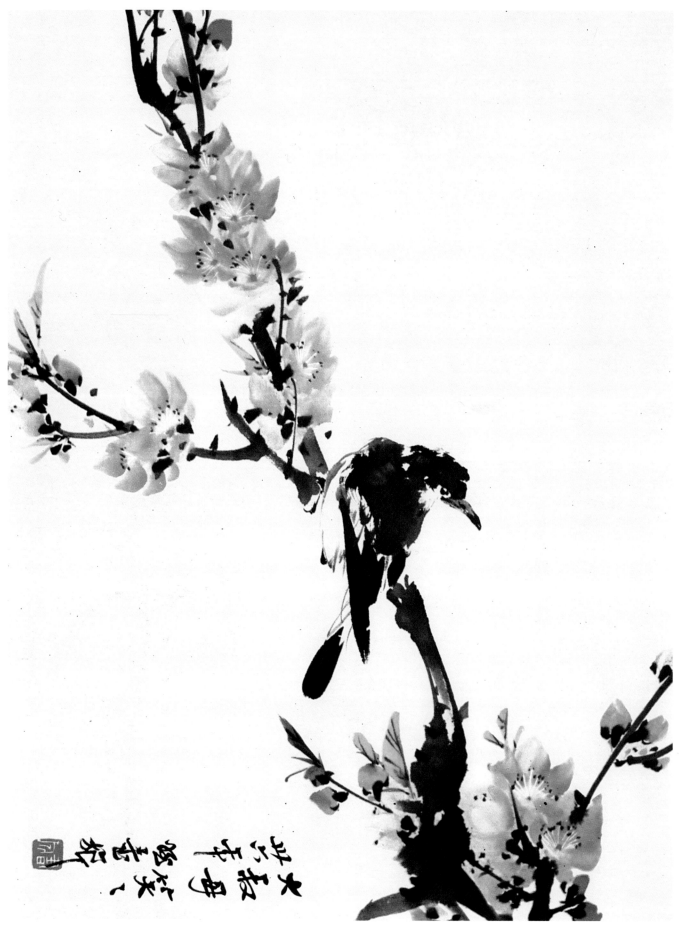

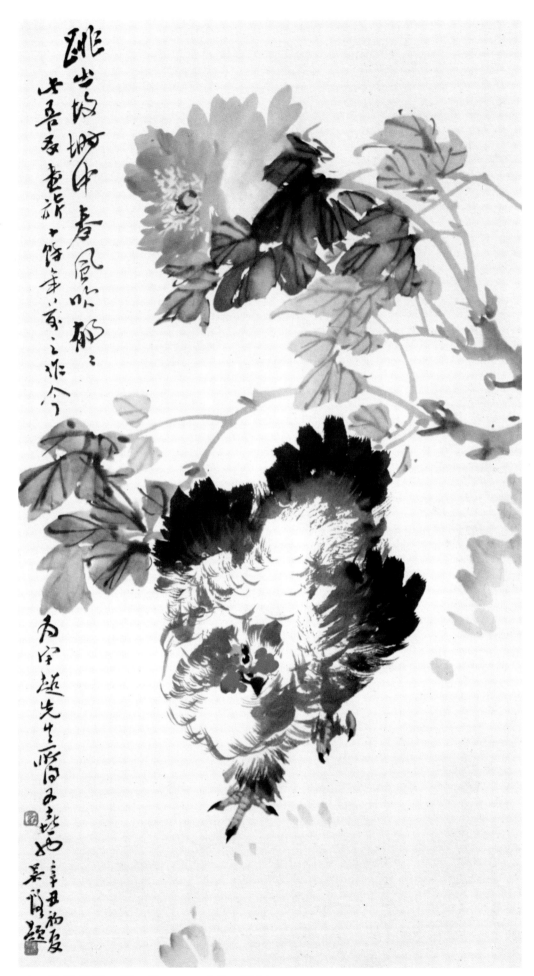

10　牡丹母鷄　The Peony and the Chicken

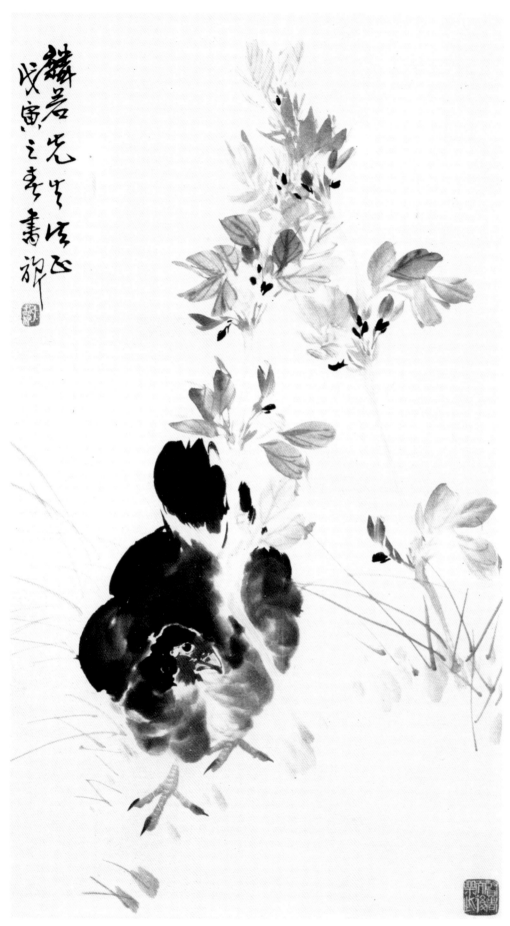

11　豌豆母雞　The Garden Pea and the Chicken

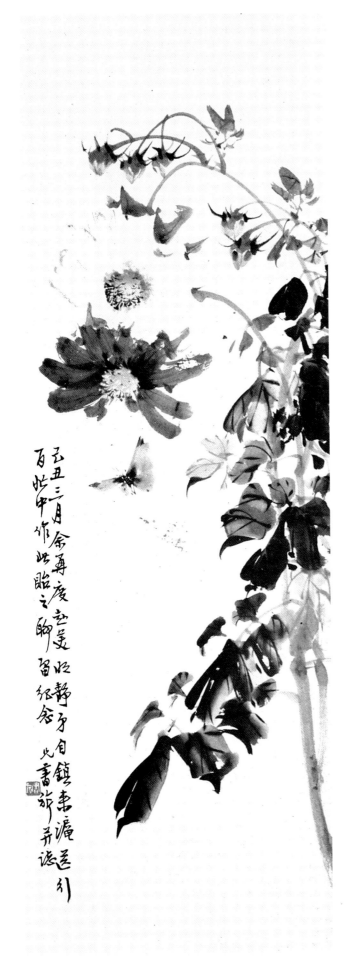

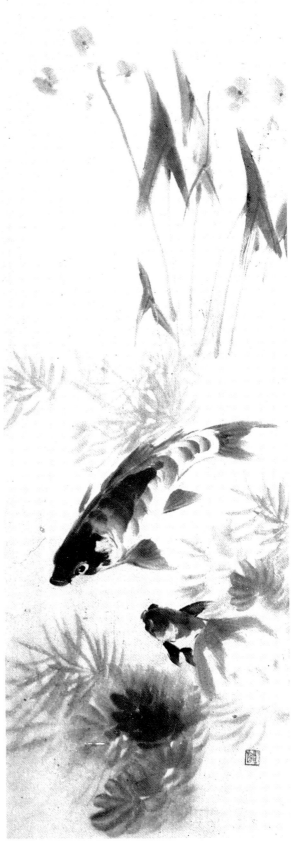

12 大麗花　The Sunflower　　　　13 魚　Fishes　　　　55

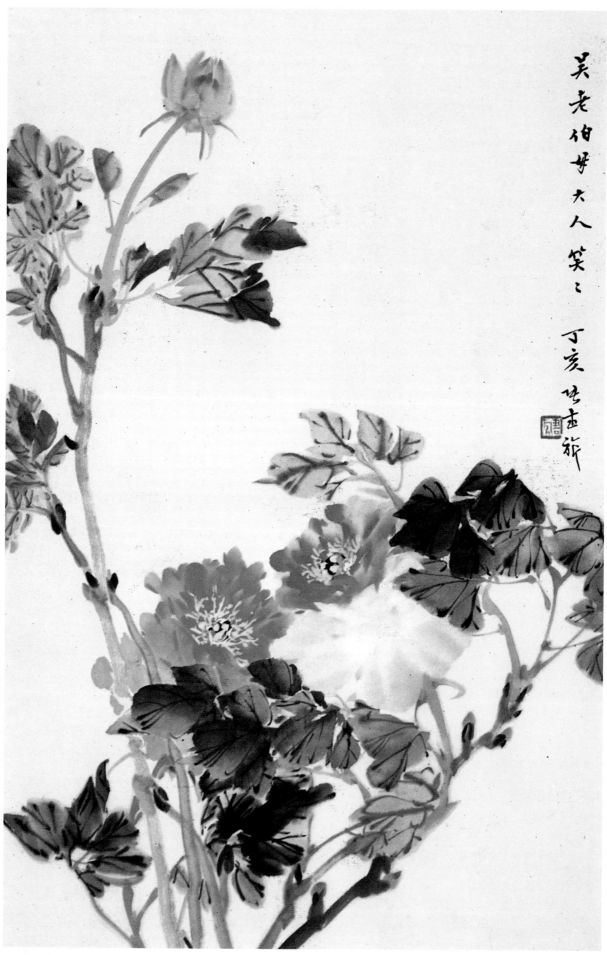

吳老伯母大人笑之

丁亥清畫於

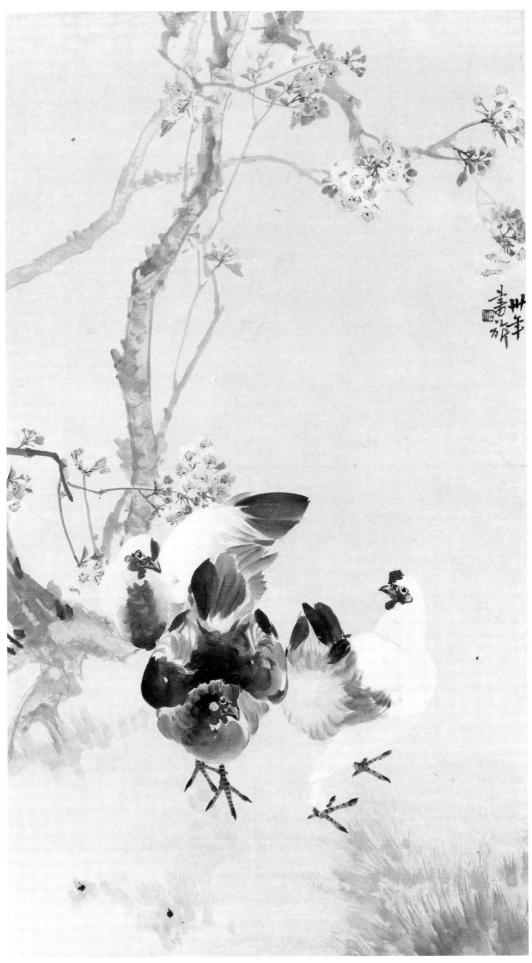

15 海棠母鷄 Peach Flowers and Chickens

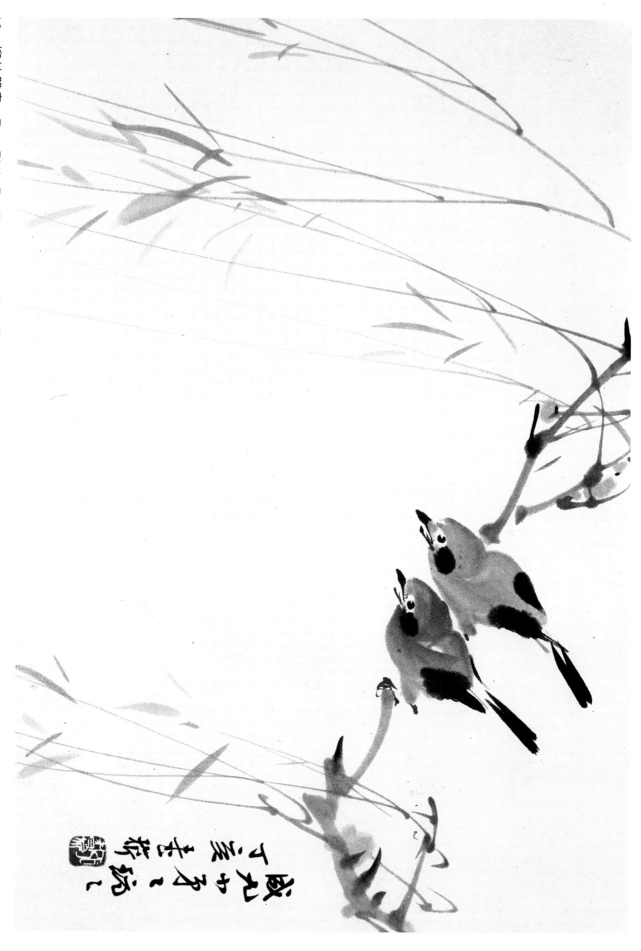

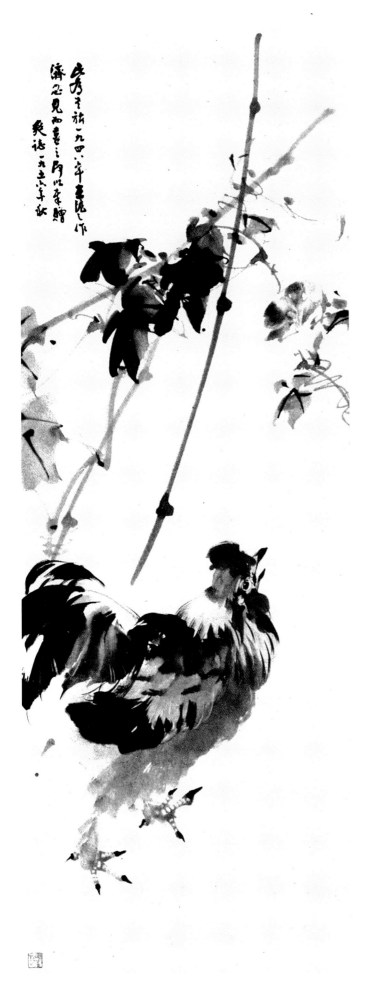

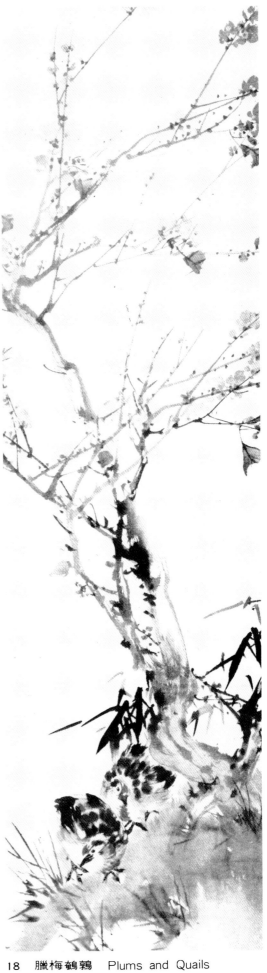

17 牽牛花雄雞 The Morning Glory and a Chicken

18 臘梅鵪鶉 Plums and Quails

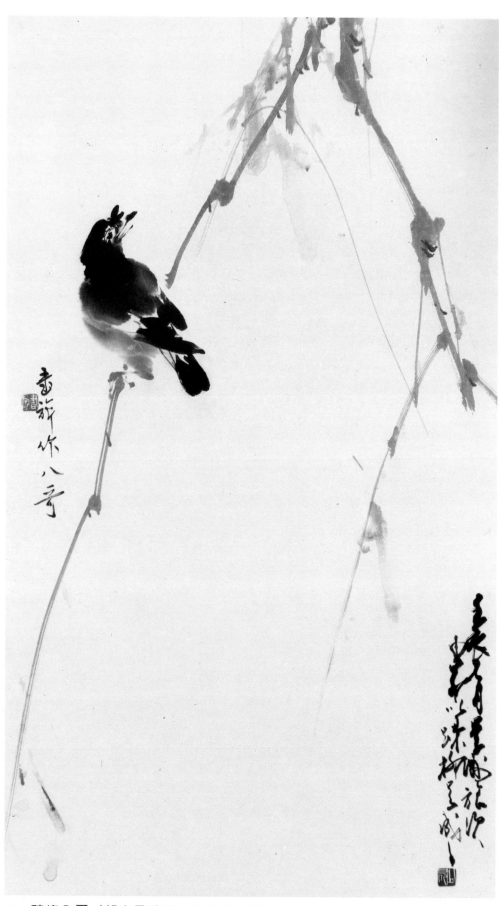

19 疏柳八哥 （趙少昂疏柳・張書旂八哥）
The Mynah on a Willow Branch

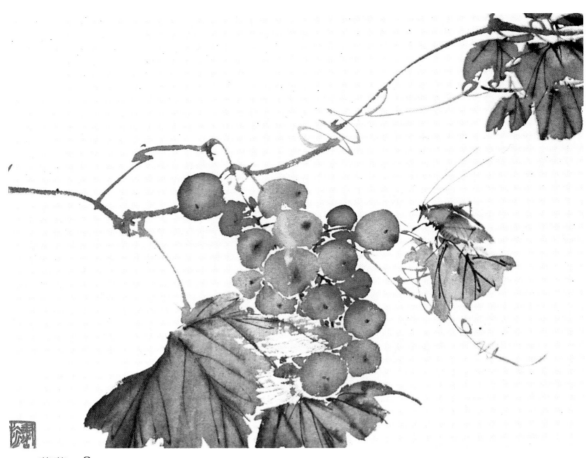

20 葡萄 Grapes

21 魚 Fishes

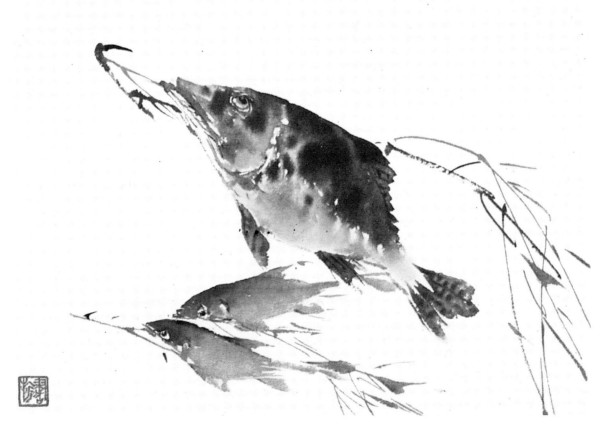

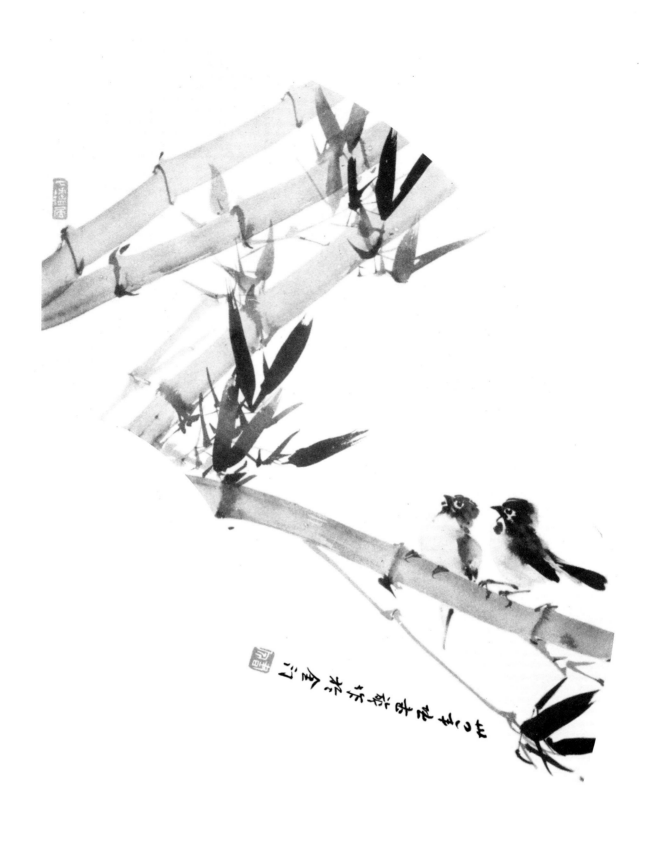

22 竹雀 Bamboos and Sparrows

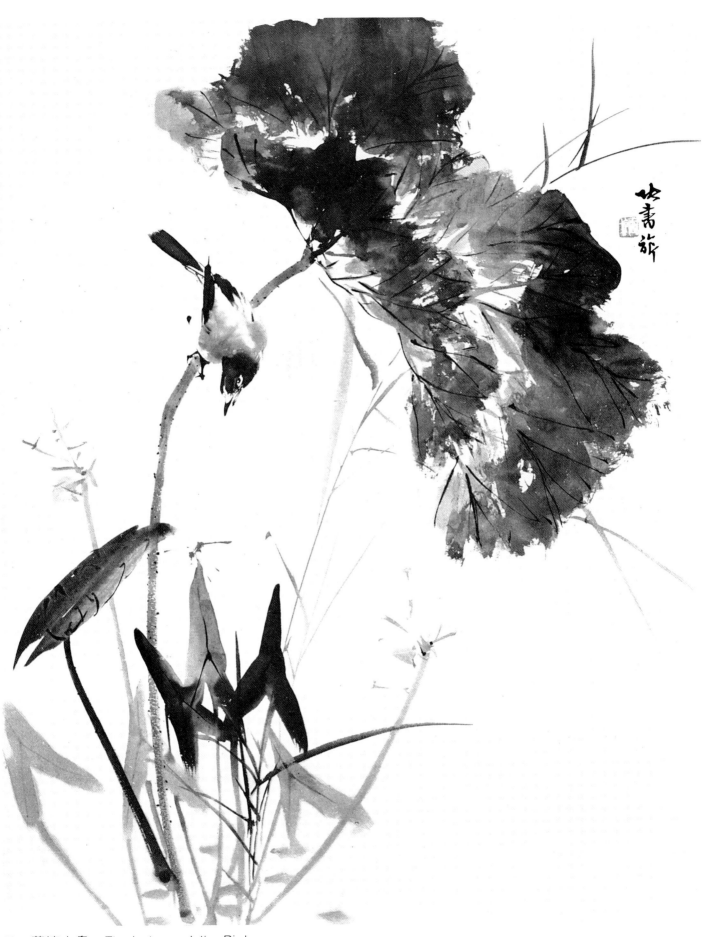

23　荷塘小鳥　The Lotus and the Bird

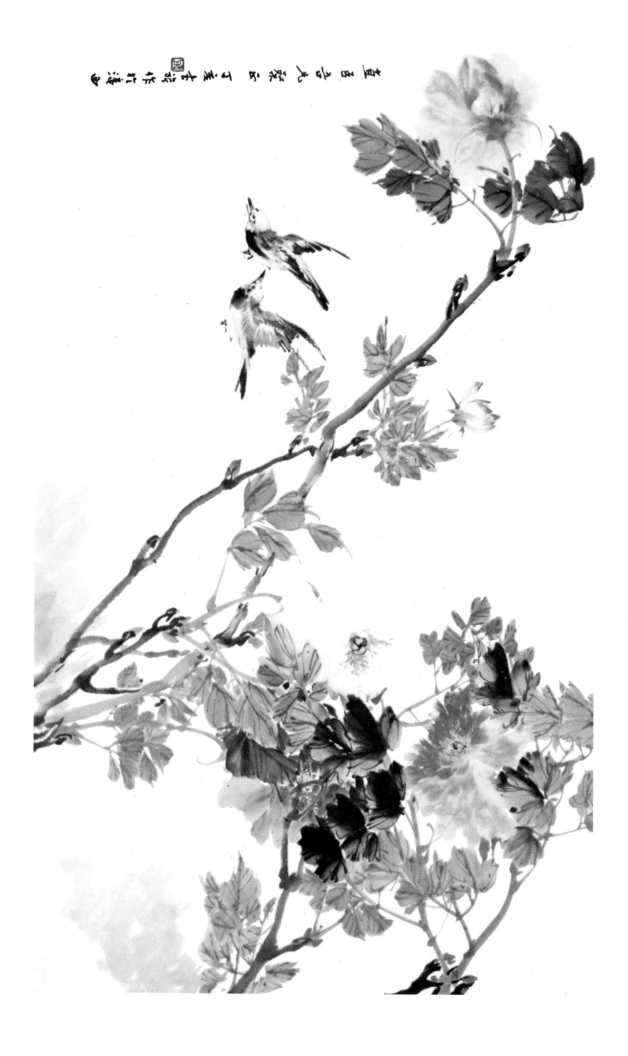

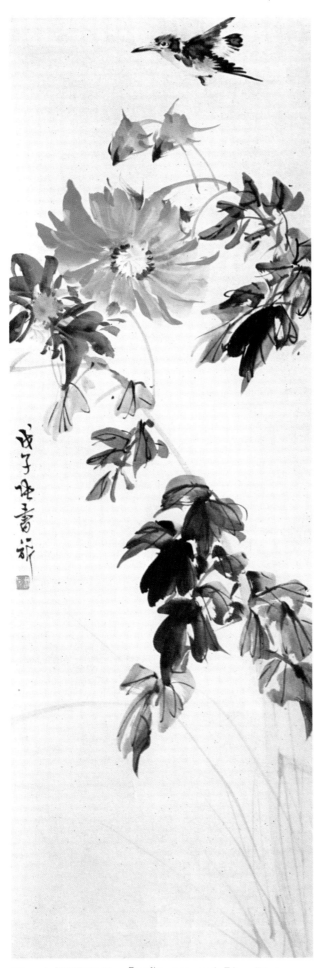

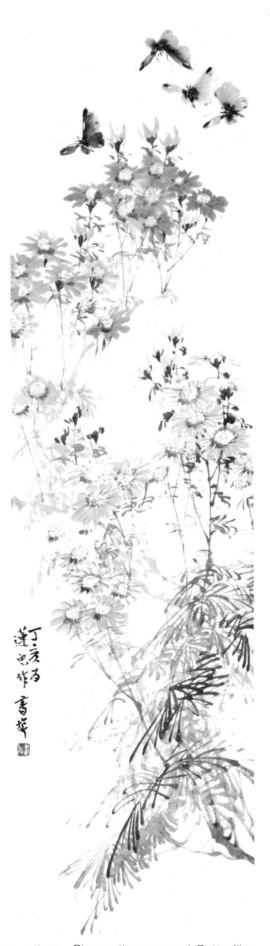

25 大麗花翠鳥 Sunflowers and Blue Birds 26 菊蝶 Chrysanthemums and Butterflies 65

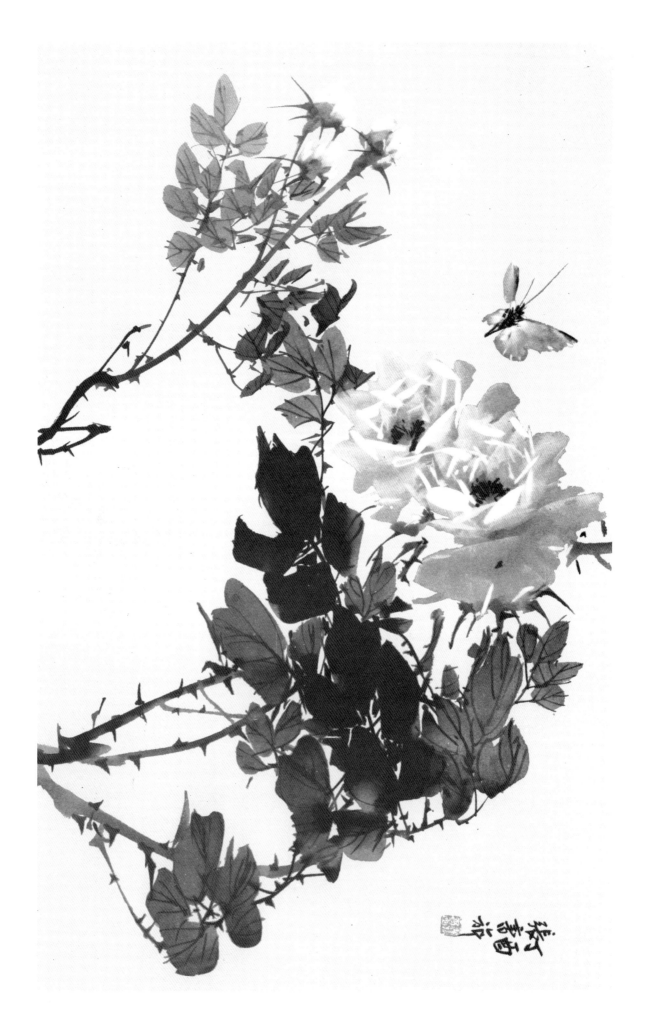

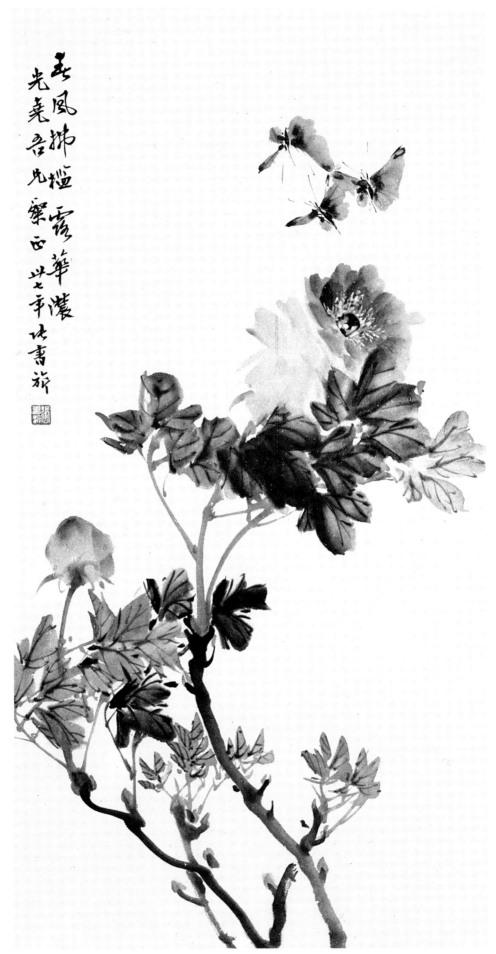

春風拂檻露華濃

光堯吾兄疋正 此七平此書於

28　牡丹蝴蝶　The Peony and Butterflies

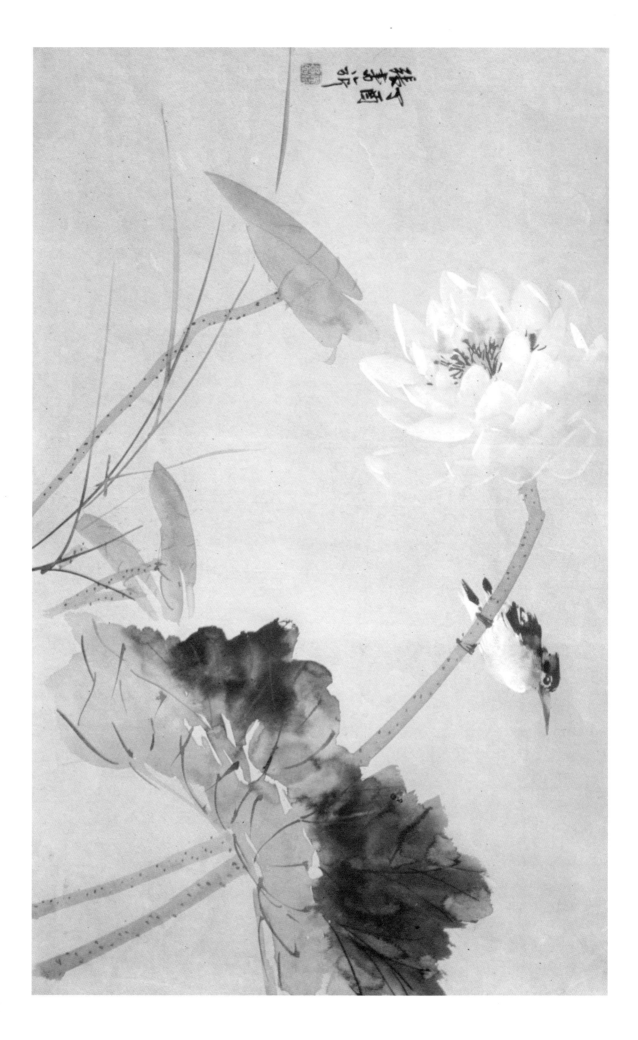

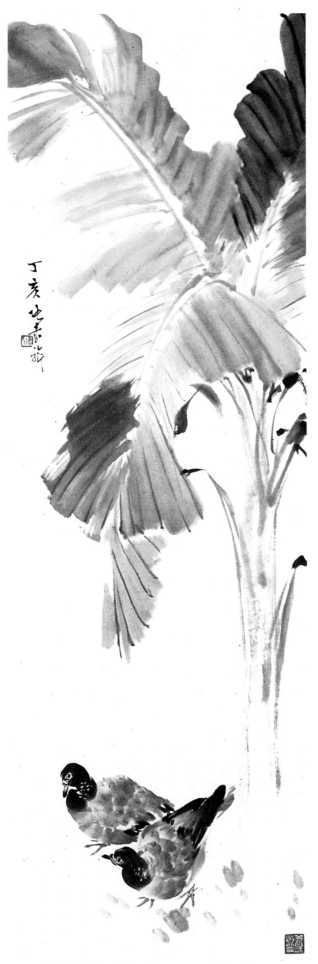

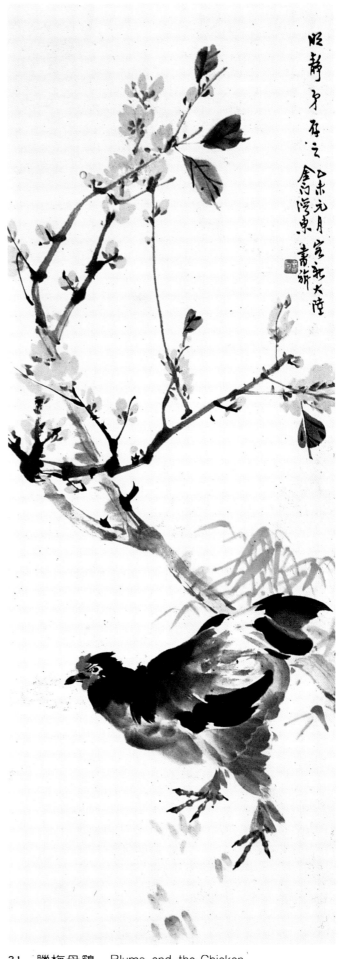

30　芭蕉鴿子　Palm Leaves and the Doves

31　臘梅母鷄　Plums and the Chicken

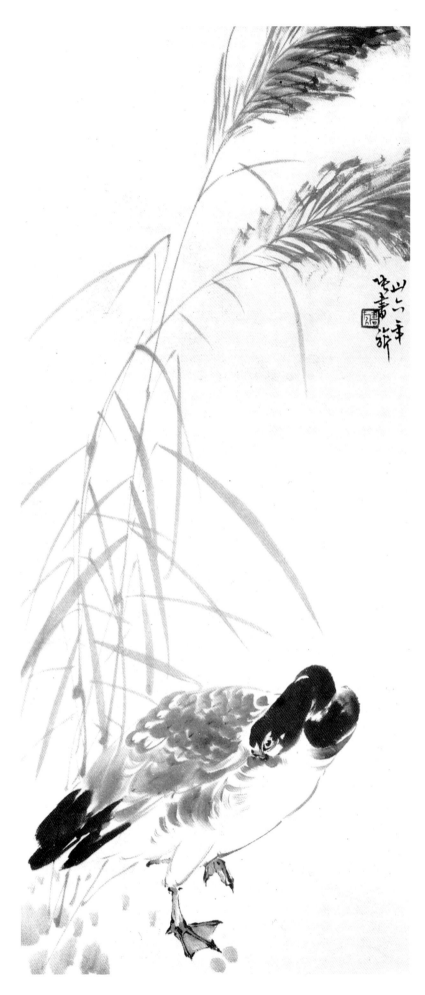

32 雁 The Wild Geese

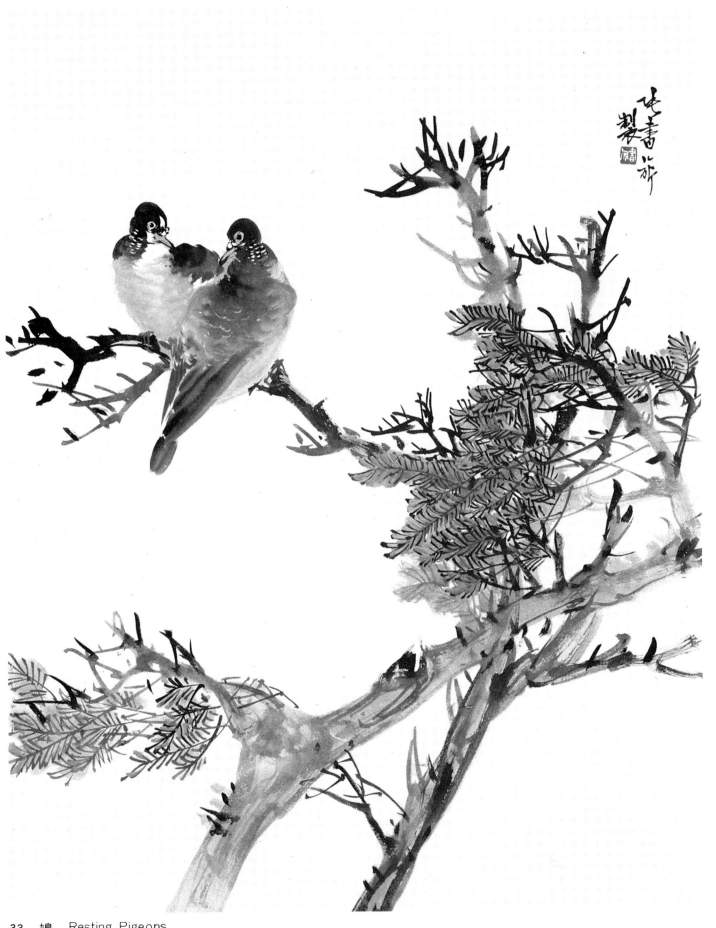

33　鳩　Resting Pigeons

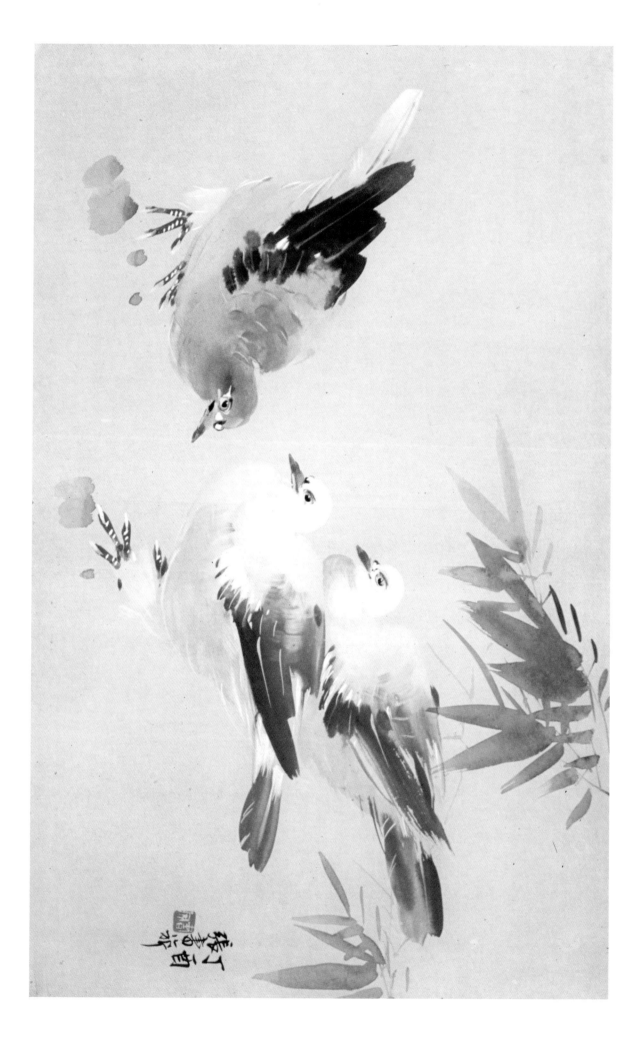

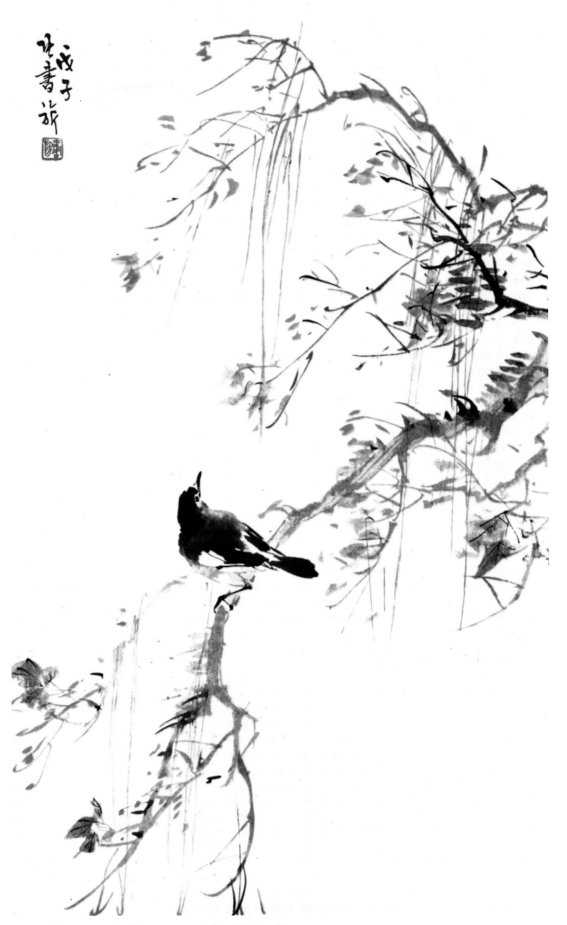

35　秋樹小鳥　A Sparrow and the Winter Tree

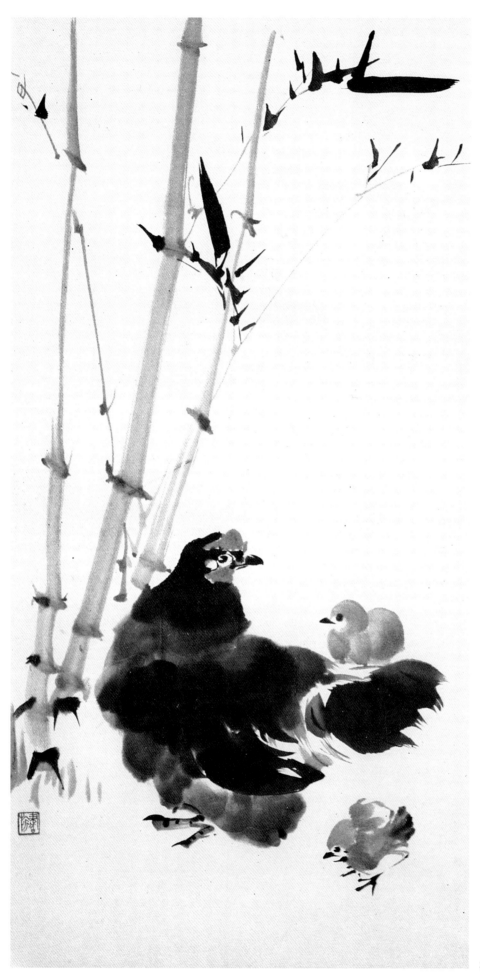

36 母子圖 Mother and Sons

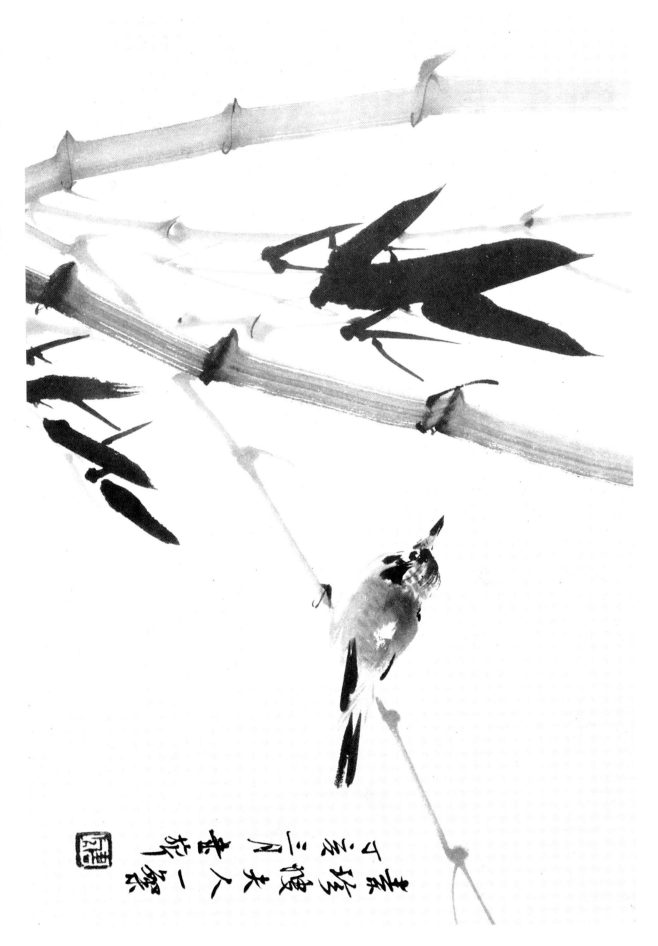

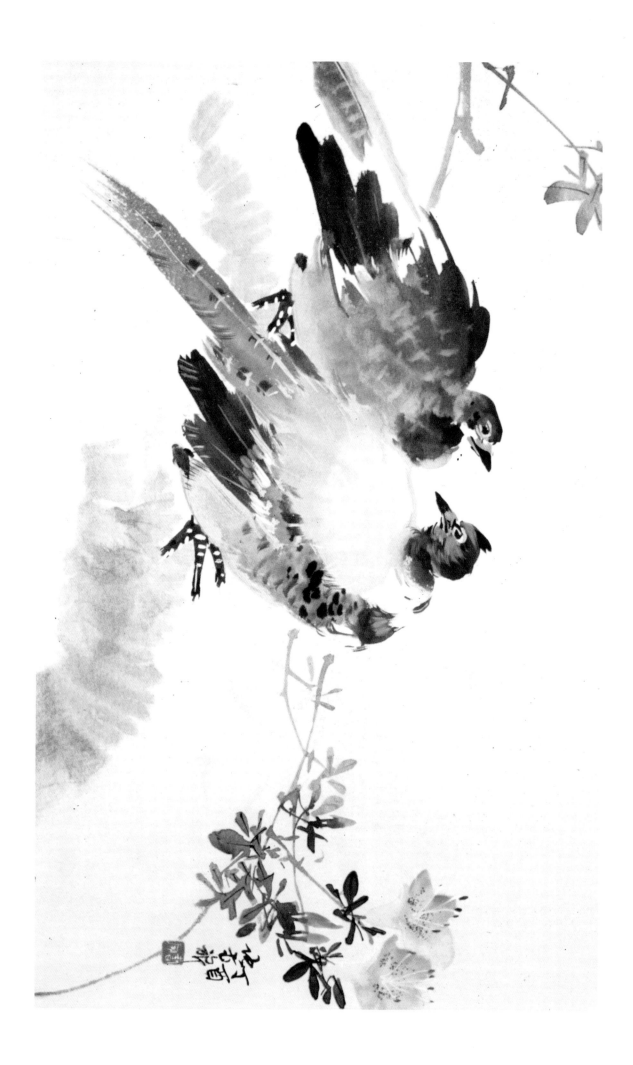

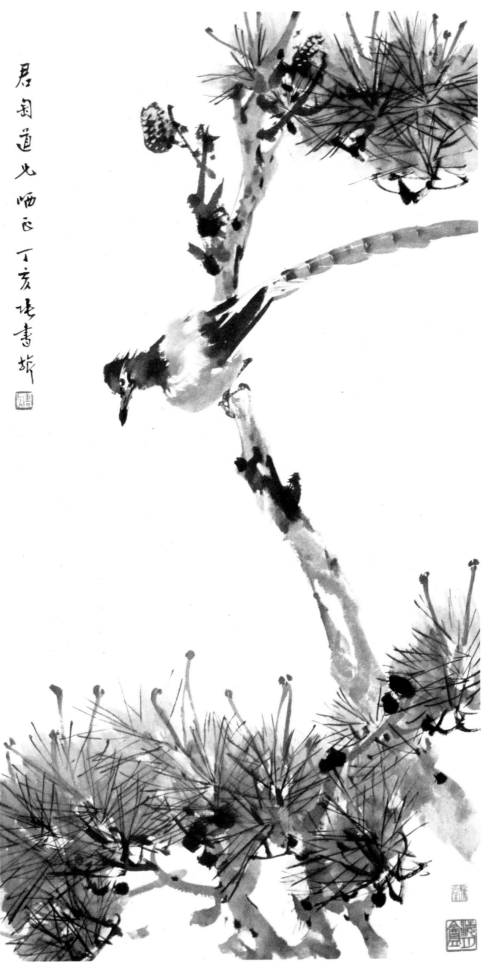

君闔道光師正 丁亥□書坫

39　松鳥　A Bird on a Pine Tree

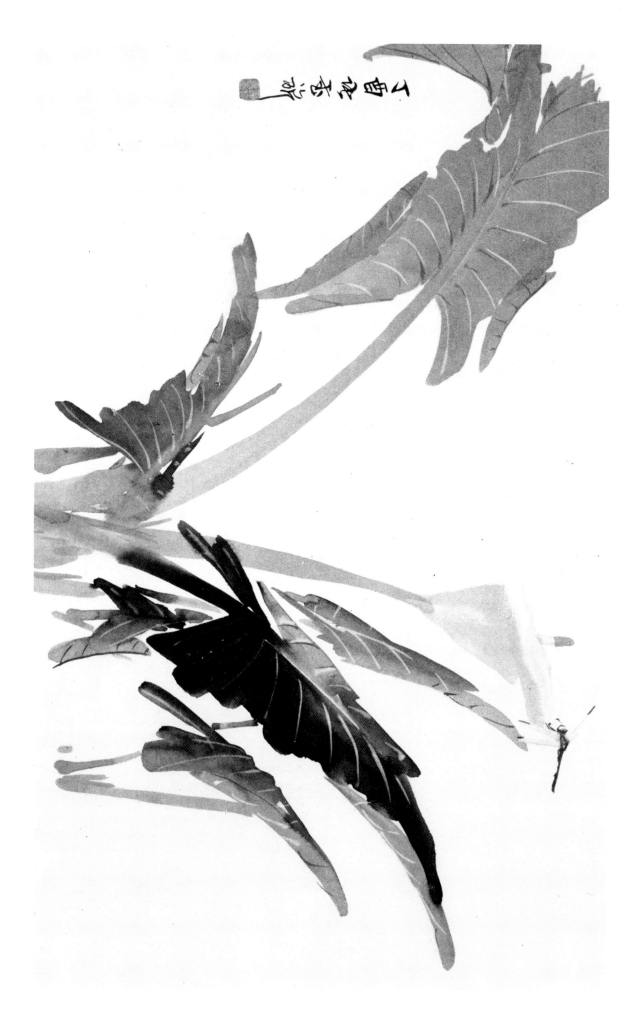

41 雁 Wild Geese

書旂老弟
屬寫活鴛
鴦麗不同凡
細書極為姓
人所珎重此
幀為其二次
渡美前之難得
白尤為難得
辛正秋壽
懸栈生畫

80　42　雙雉　A Couple of Turtle Doves

玉邨春月淘江琦畫於宫古渝州

43 扁豆小鳥　The Beans and a Bird

陶令籬邊花火的斗杯泛金英延年益壽

丁卯夏罗貼廣兇書於

44 菊花　Chrysanthemums

81

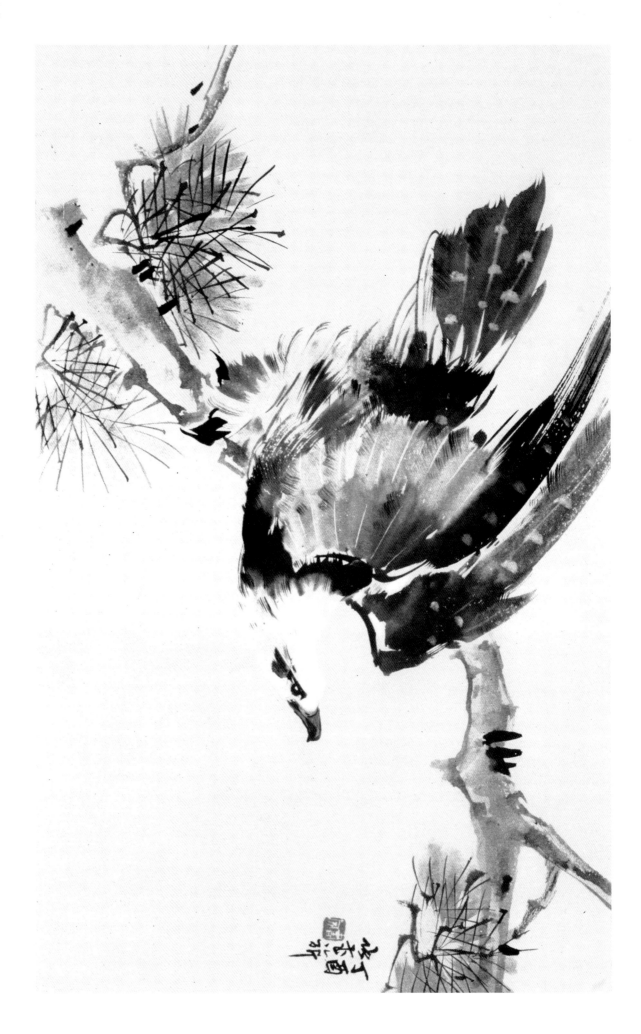

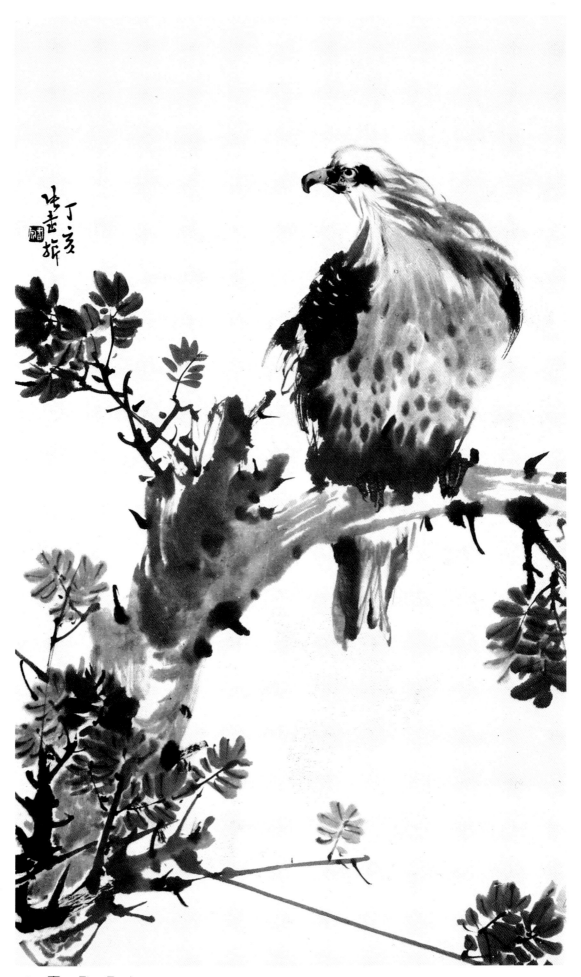

46 鷹　The Eagle

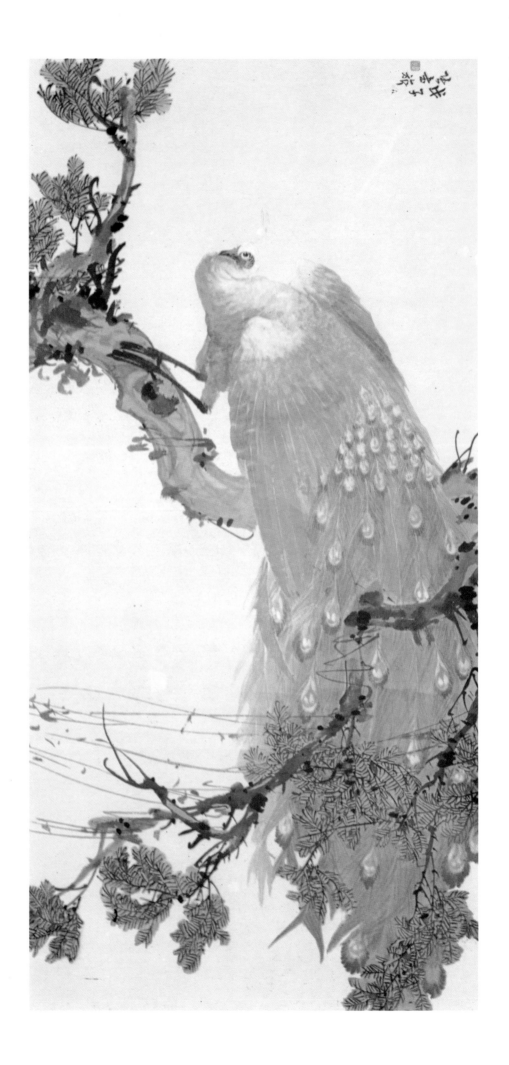

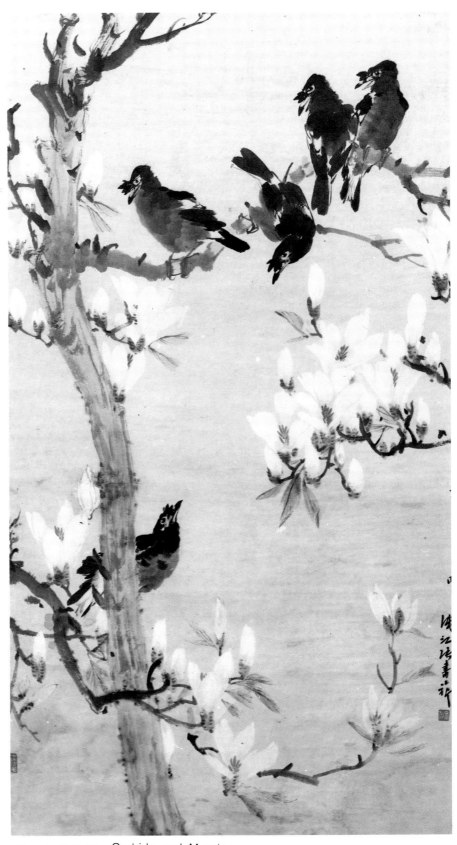

48　木蘭八哥　Orchids and Mynahs

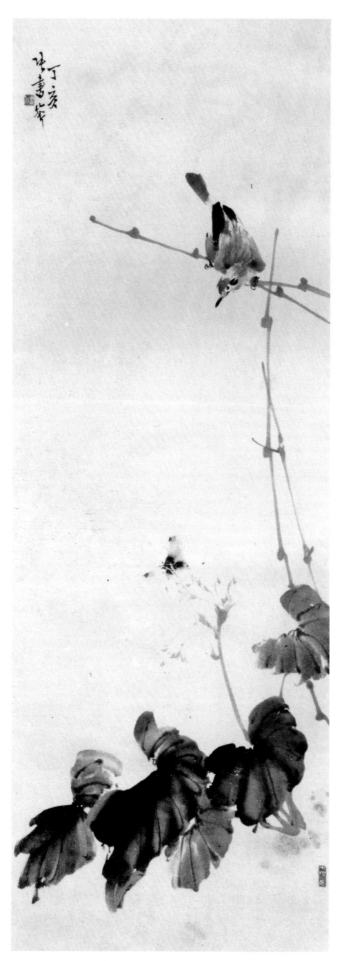

49　玉簪小鳥　The Tuberoses and Birds

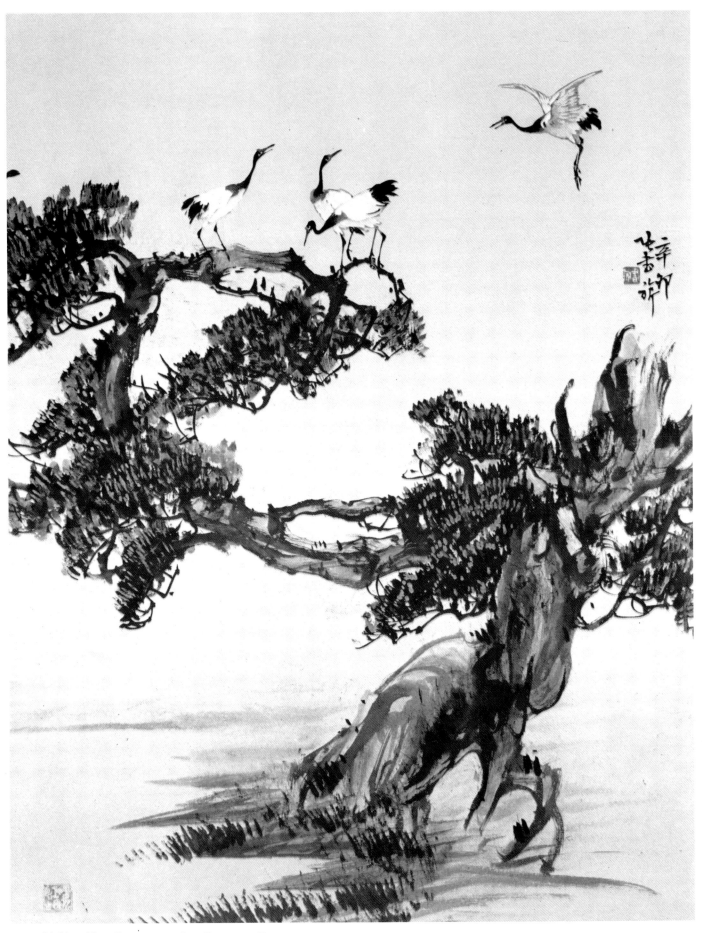

50 柏鶴 The Cranes on the Cypress Tree

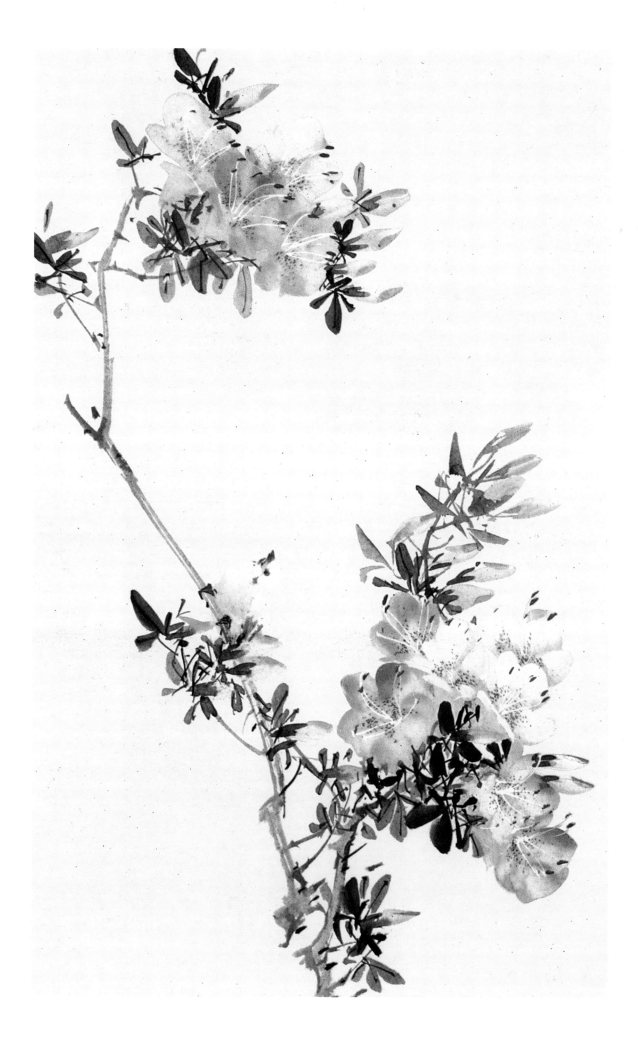

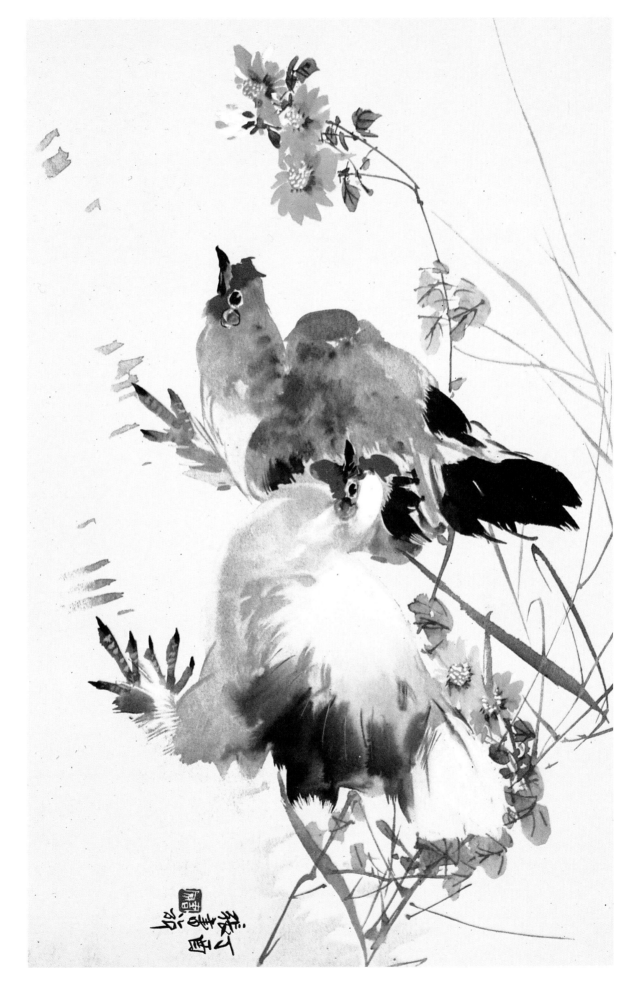

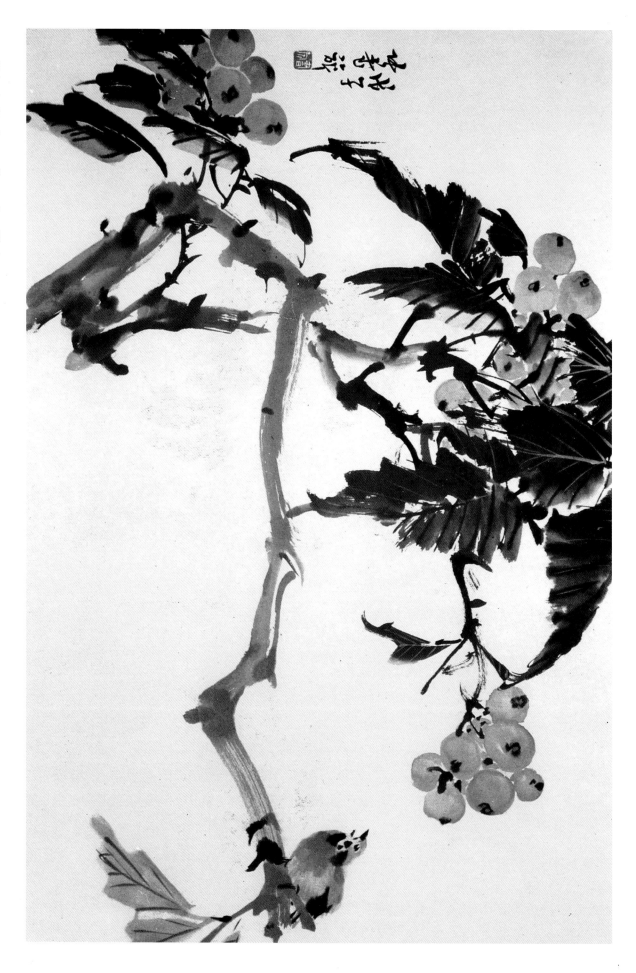

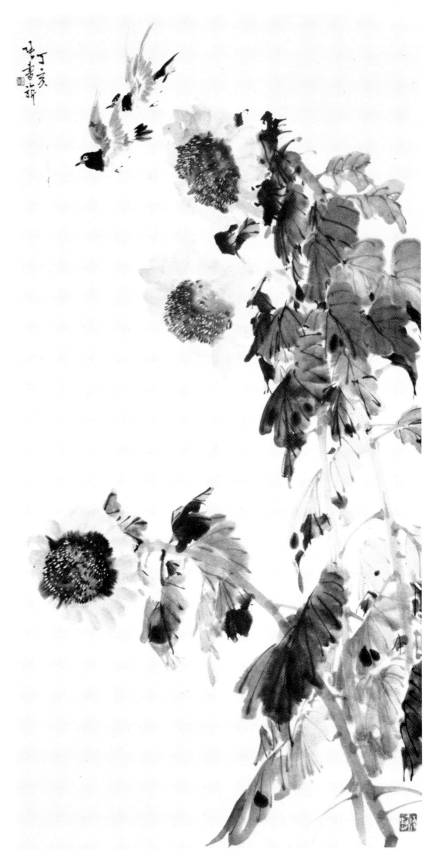

54 向日葵 The Sunflowers

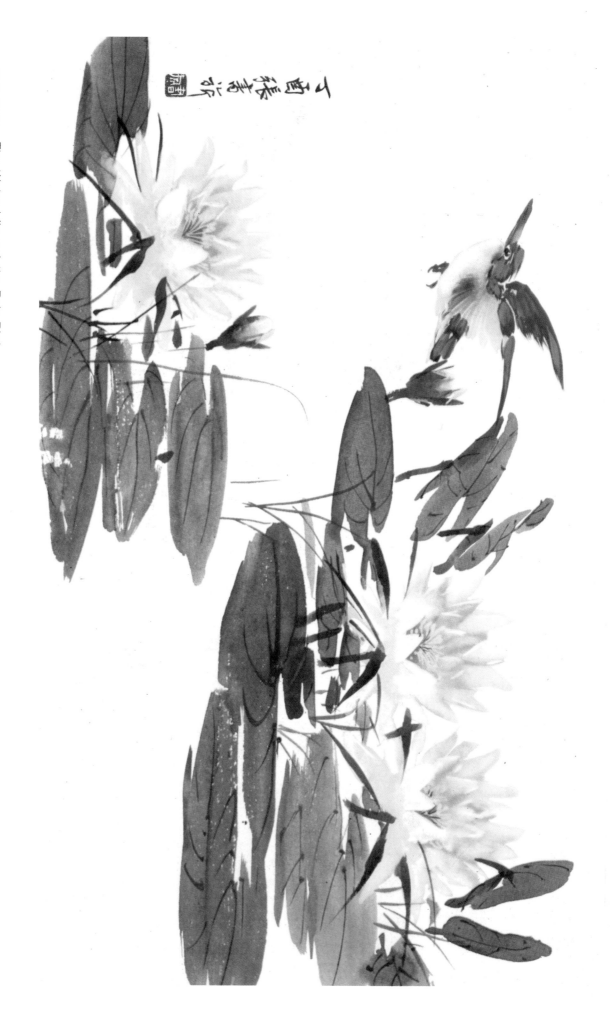

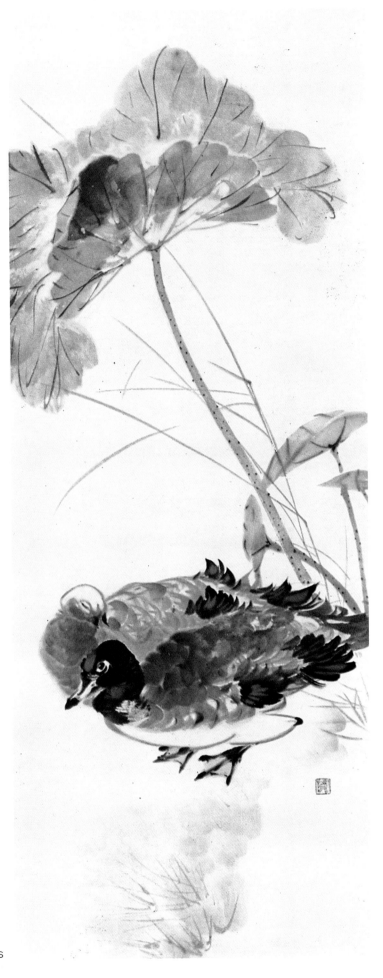

56 荷葉雙鳧
Lotus Leaves and a Couple of Pigeons

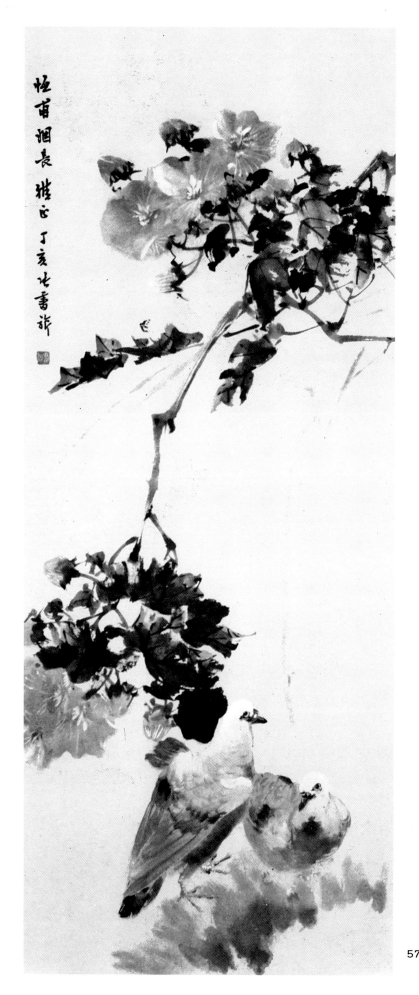

57　芙蓉雙鴿

The Lotus and a Couple of Doves

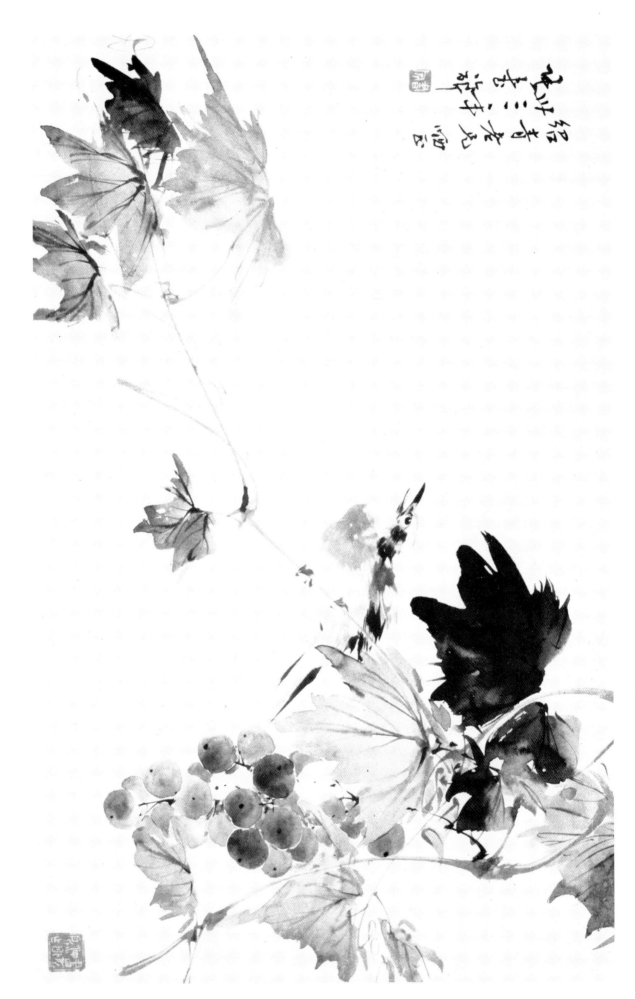

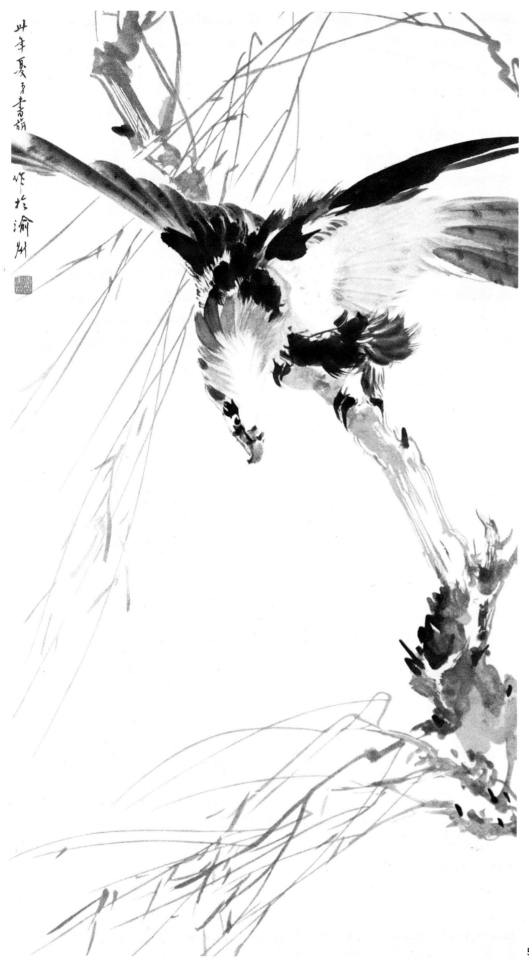

59 鷹 Eagles

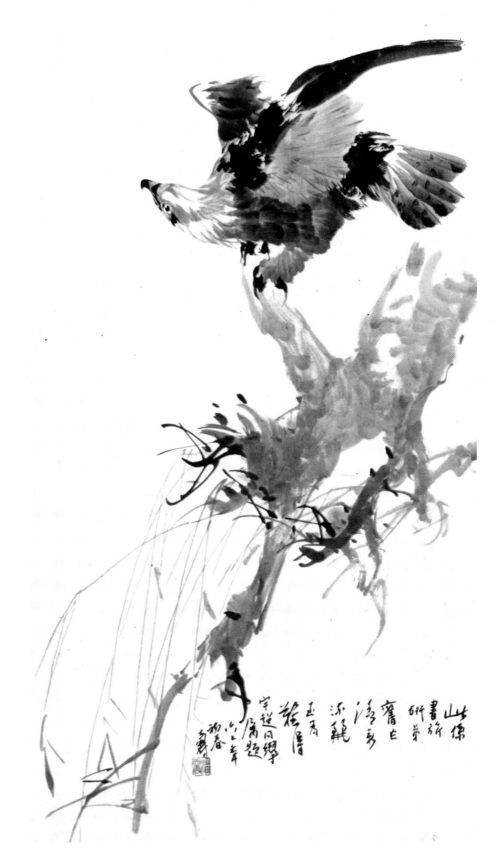

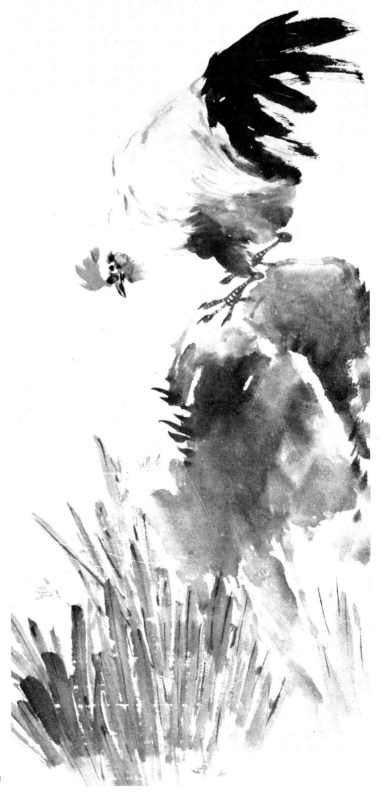

62　雄雞蝴蝶花　The Chicken

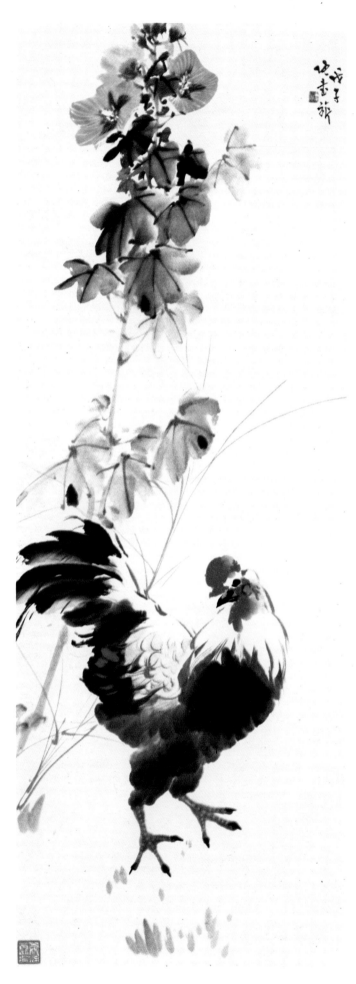

63　蜀葵雄鷄　The Chicken and Sunflowers

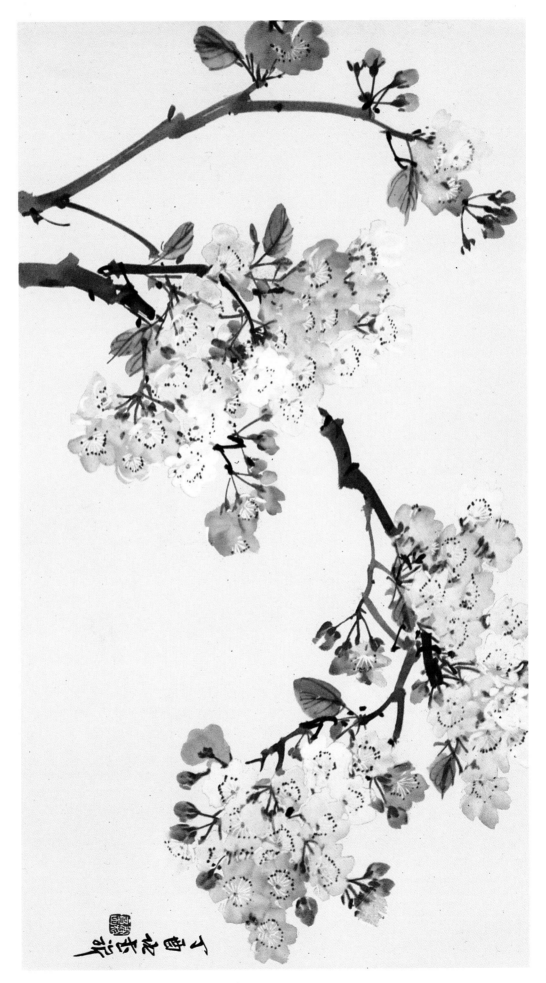

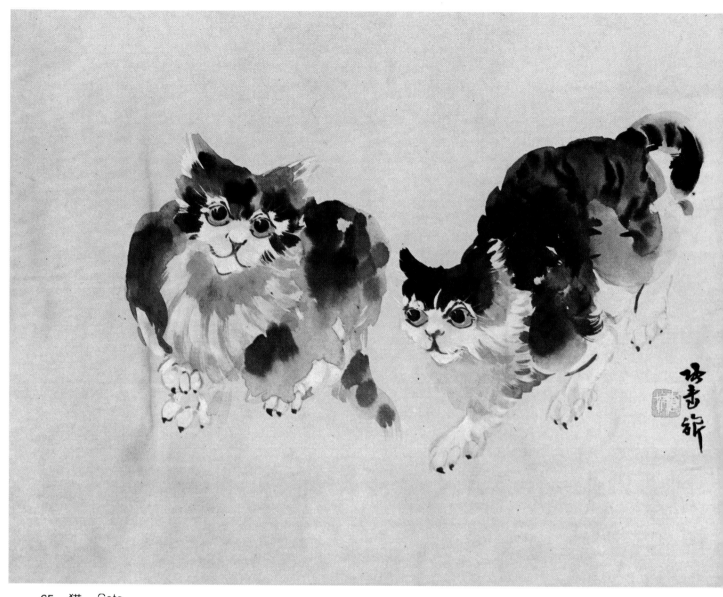

65 猫 Cats

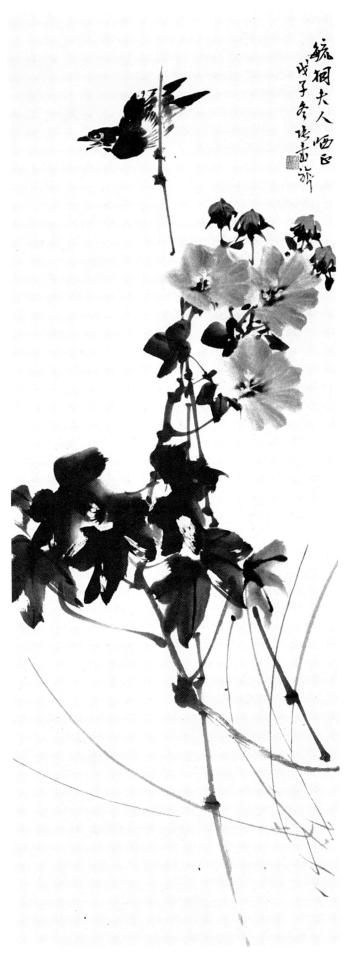

66　芙蓉　The Lotus

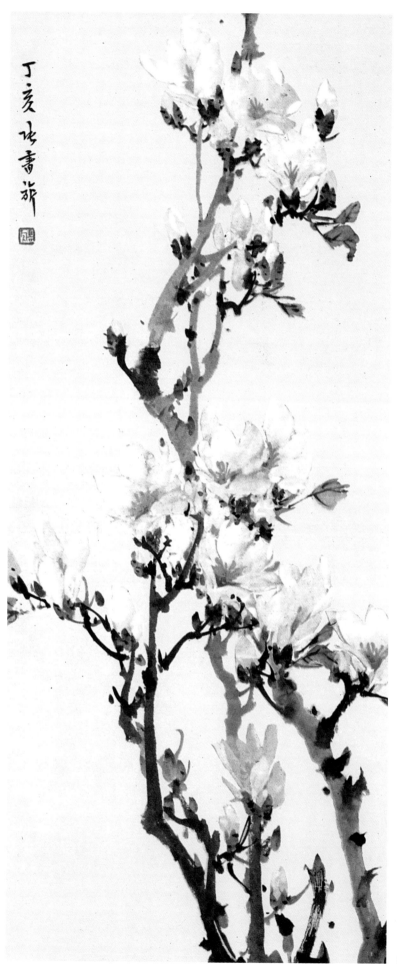

67 玉蘭 The Orchid

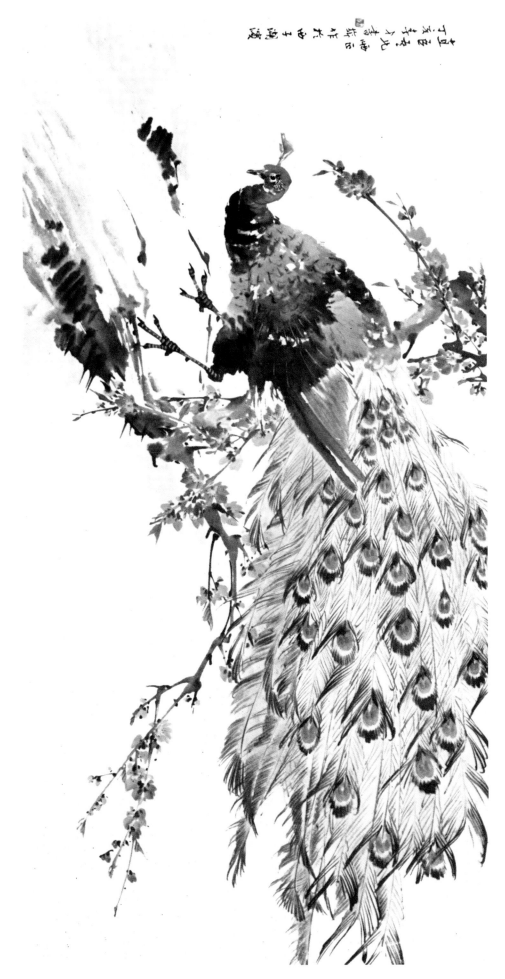

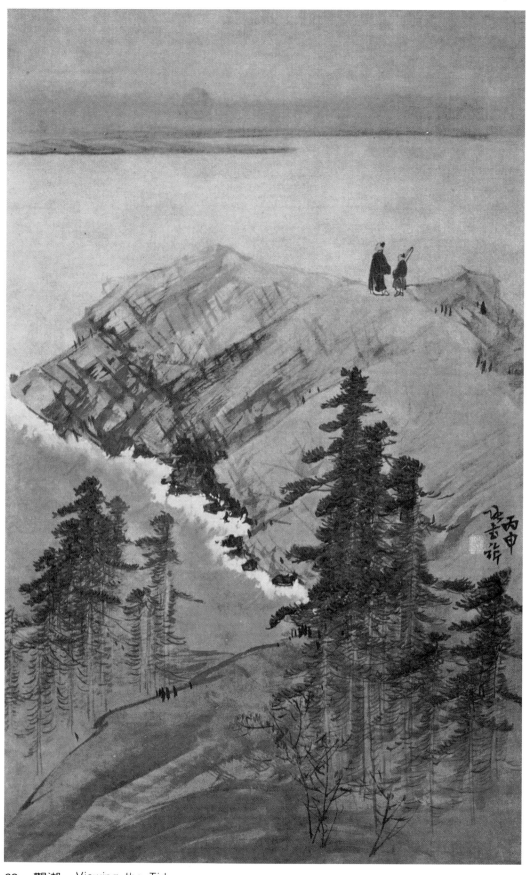

69 觀潮 Viewing the Tide

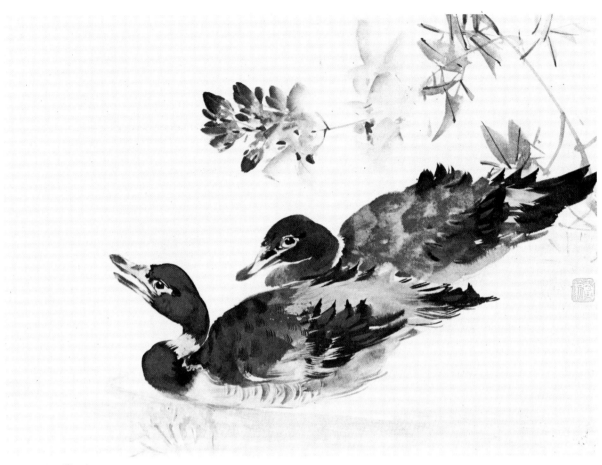

70　鴨　Ducks

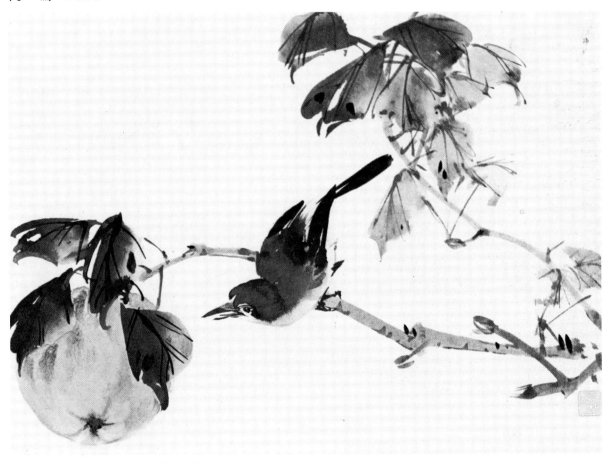

71　果熟引雀來　Ripe Fruit Brings Hungry Sparrow

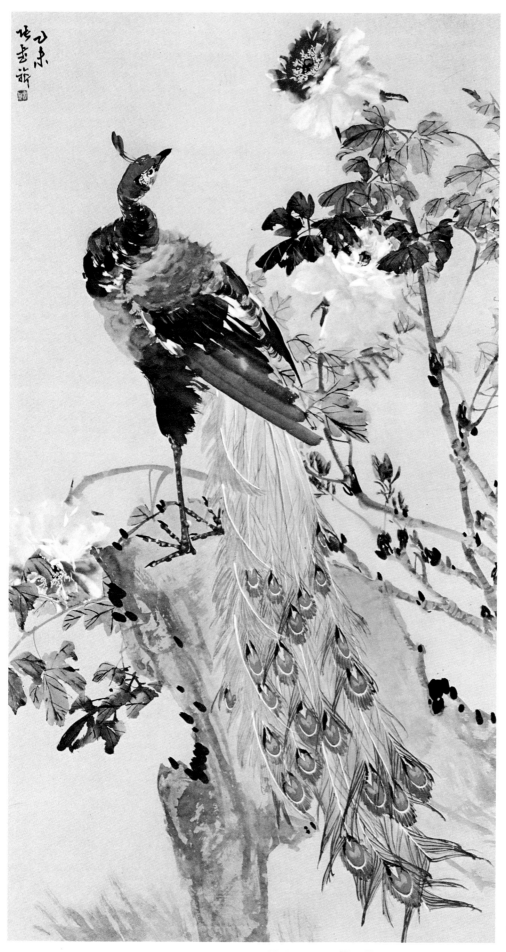

72 孔雀牡丹 The Peocock and Peanies

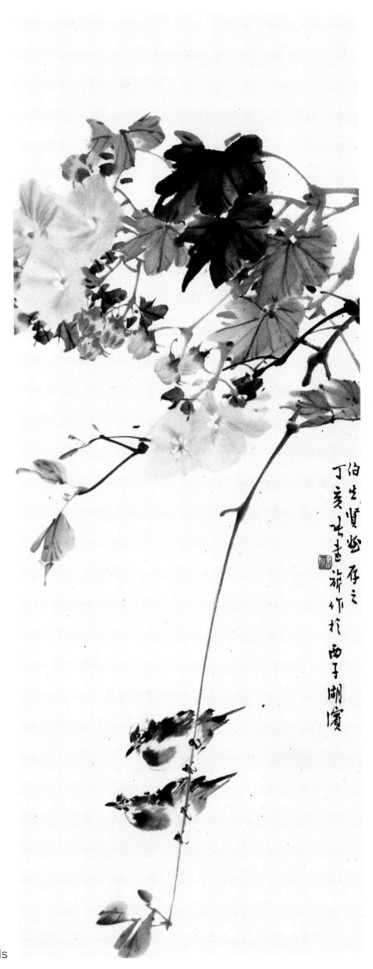

73　芙蓉小鳥　The Lotus and Birds

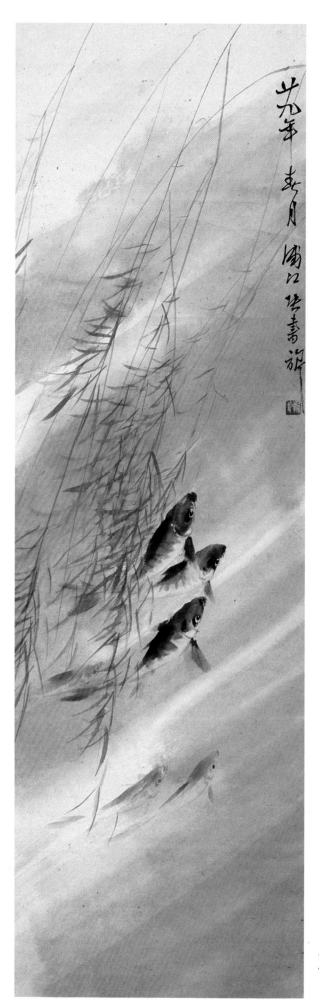

74　柳絮游魚　Willow Catkins and Fishes
75　柳絮游魚（局部）(Detail of 74)

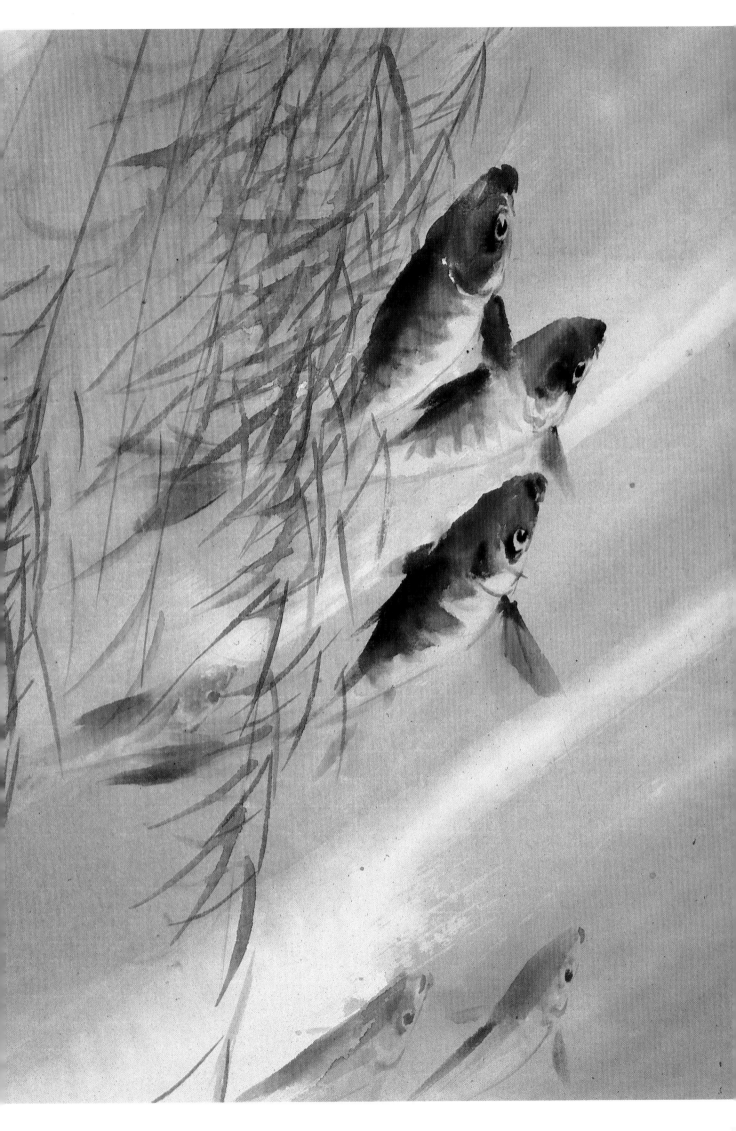

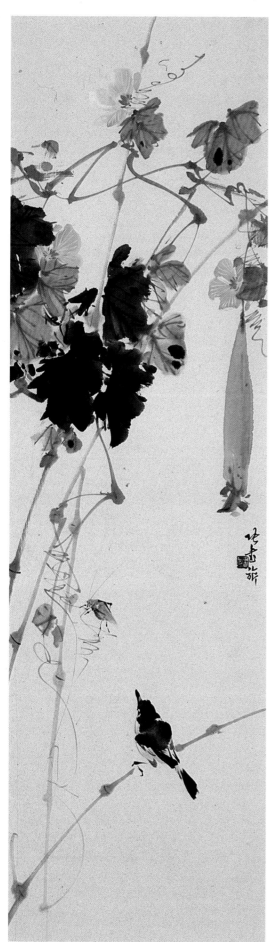

76 絲瓜小禽 *Loofah Gourd & Birds*

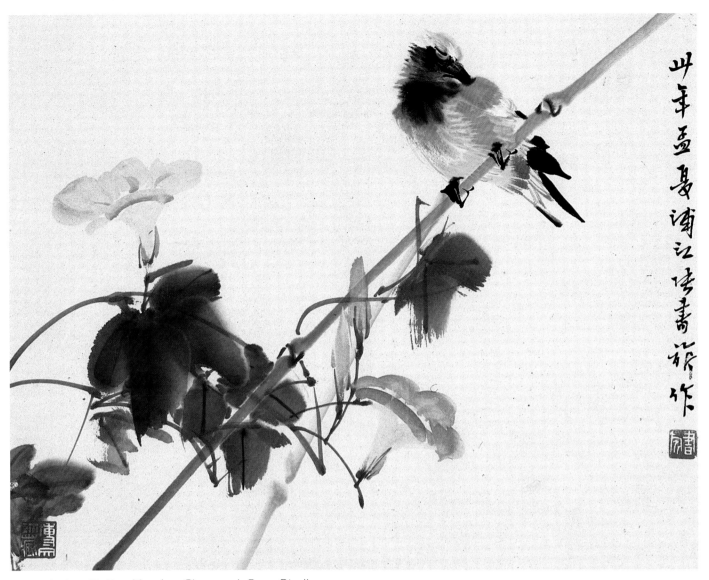

此年孟冬浦江陸書荘作

77　牽牛白頭翁　Morning Glory and Grey Starlings

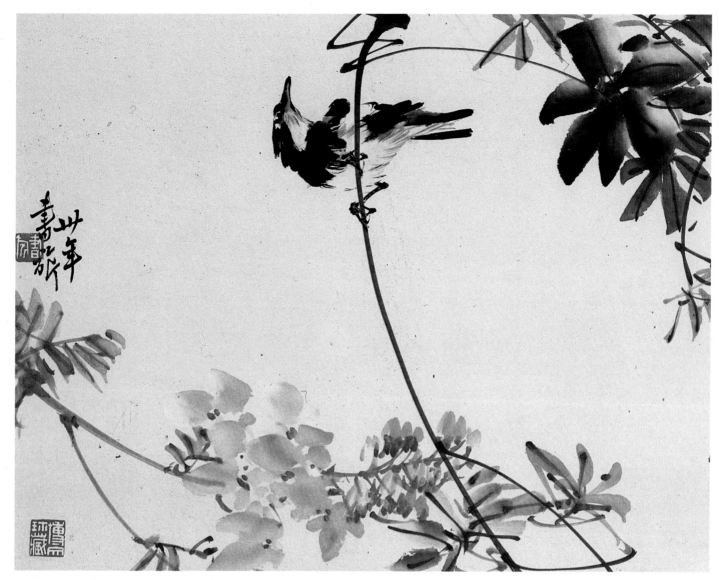

78　紫藤小鳥　Witaria and Bird

M001
中國花卉畫基礎㈠ 梅譜

M002
中國花卉畫基礎㈡ 蘭譜

M003
中國花卉畫基礎㈢ 竹譜

M004
中國花卉畫基礎㈣ 菊譜

M005
旅美畫家周士心編繪
中國花卉畫基礎

M007
四季花卉畫譜㈠ 春花

M008
四季花卉畫譜㈡ 夏花

M009
四季花卉畫譜㈢ 秋花

M010
四季花卉畫譜㈣ 冬花

M011
旅美畫家周士心編繪
四季花卉畫譜
周士心編繪
這一輯的內容是四季花卉，每季選擇重要花木各五種共二十種，編成四個分冊，每種花卉皆有綜合說明其物性、特徵，每圖亦皆解釋所採用方法與技巧，緊密銜接第一輯，並且注意中國畫傳統六法和推陳出新的效果。

M013
國畫鳥譜㈠

M014
國畫鳥譜㈡

M015
國畫鳥譜㈢

M016
國畫鳥譜㈣

M017
國畫鳥譜
周士心編繪
掌握歷史便能通古今之變，這是本書始載「簡史」之因，在這本鳥畫入門書中，一個投身花鳥畫逾半世紀的人，以豐碩不平的經驗，細細析解鳥類各種姿勢的畫法，並以各種常見之鳥反覆以實例綜合說明。是鳥畫集大成的權威著作。

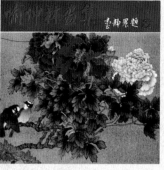

M018
金鼎獎優良圖書
喻仲林畫集
喻仲林繪著
一百幅花鳥畫創作，包括鈎勒、沒骨和水墨點染技法，欣賞及參考非常適宜，被喻為近三十年最受歡迎畫集。

 Moon-shaped Fan 喻仲林花鳥畫稿 by Yu Chung-lin

M019
喻仲林 團扇之美
喻仲林繪
團扇之美在精雅、小巧、細膩；團扇之畫本來是古代畫家在夏日，拿在手上的搖扇，自己手繪。現在變成國畫畫種之一。喻仲林生前畫了很多小小的扇面花鳥畫，確是巧巧的完美世界。
●167幅團扇作品·全部彩色印刷

M020
喻仲林 扇面之美
喻仲林繪
這是喻仲林生前遺留的畫稿，每一幅都等於是完整的作品，每一張扇面說明了喻仲林先生的夢，看到他付出卅年光陰歲月，將花鳥繪畫拓展成一片自在的生機。
●156幅彩色扇面作品·彩色印刷

M021

M021
伍揖青工筆畫集　伍揖青編繪
他的牡丹——濃姿富貴，生光如洗。
他的荷花——如生對雨，婀娜多姿。
他的寫竹——臨風取勢，如聞秋聲。
他的梅花——仿如傲骨，抬頭挺胸。
他的翎鳥——茸細柔潤，活潑生動。
他的麻雀——憨態可掬，隻隻如生。
伍揖青筆下的工筆花鳥，畫盡名花奇卉、翠羽靈禽。他筆下花花葉葉、片羽隻翎，柔美絕俗，嚴謹法度，氣勢不凡，鮮豔求雅，引人入勝。
●120幅工筆作品·彩色印刷

M022
工筆寫意畫譜
草蟲花鳥畫譜　伍揖青繪著
本書把大自然的野趣春情，一草一木一花一葉，一蟲一蝶一鳥一魚，以妙筆寫來神采飛揚，是本極佳畫譜。

M023
群芳譜　伍揖青編繪
飄逸、淡雅的畫風，洗淨塵世的污染。伍揖青費時五年的工筆花卉，若173首淸麗小調；細細品味，這些尋常題材，顯露了不凡的氣勢，似在傾訴作者個人的哲學與內在情懷。每幅畫皆有專文介紹說明及題畫詩，是畫與詩的結晶。
●190頁 179張彩圖 2萬字

M026
故鄉水　●趙澤修攝影集
水，在中國人的日常生活和哲學意義上都佔有重要的地位。旅居夏威夷的畫家趙澤修；為了拍攝「故鄉水」七次進出大陸，他努力強調詩情畫意的藝術性，和更傳統的中國情懷，同時注入個人對故鄉之水的眷念。
●140頁 黑白印刷 設計精美

M027
港台最豪華彩色畫冊
趙少昂畫集
豪華精裝·30cm×30cm·180頁
畫家自藏精品178幅·全部彩色印刷

嶺南　一代宗師趙少昂，今年八十高齡，繼承和發揮了嶺南高奇峰、高劍父的渲染技巧，更發展了撞水和撞粉的功能，為嶺南畫派再拓新局。本書集由大師親自精選一生代表作，全是公開的精品。

M028
可裝框、可欣賞、可教學
趙少昂小品選輯
畫家珍藏三十年小品冊頁

趙教授的大幅巨製，瑰麗雄奇。而他數十年的功力所聚，更現諸於冊頁小品，就筆墨、色調、形象、構圖、題畫、意境之精妙處而言，亦堪稱藝壇一絕。

M032
楊善深畫集
楊善深繪著

嶺南畫派出身，敢於創新的精神使他成為當代楊派的開山祖師。楊善深是一位書畫藝術的多面手，其山水畫誘發觀畫者進入畫的意境、其竹畫風姿雋秀、其裸女畫浪漫高雅、其書法則蒼莽古拙……在本書精美的版面設計配合之下，皆令您愛不釋手！
● 179頁 3張黑白圖 154張彩圖 彩色精印

M033
黃君璧作品集
黃君璧繪著

一位高齡九十仍堅持於畫藝的畫家。作品以山水畫為主，尤以雲海和瀑布展現獨特風味。以其一生歲月傾投於山水畫，您能了解其中道理麼？或許，本書可以幫助您尋得線索。
● 179頁 60張彩圖 中英對照

M036
精印山水花鳥120幅
黃磊生畫集
黃磊生繪著

黃磊生的山水在輕描淡彩中，將山光雲影日色水聲，描繪得明媚鮮艷。花鳥重視爛漫春光，是美和詩的結合。

M037
歐豪年彩墨精選
繪著者：歐豪年

嶺南新一代的偉人歐豪年的作品，由於紮實的寫生功夫，以及西畫水彩技法的運用，很容易引起大眾的喜愛。他除講究傳統筆墨外，同時顧及到一般人的審美癖好，做到了「上士而下達」的境地，這是他在英年能享大名的主要原因。——藝評家楚戈
● 彩墨精選：山水 56 幅、人物 7 幅、翎毛、花草、蟲魚 34 幅。全部彩色。

M038
高逸鴻書畫集
高逸鴻繪著

美術評論家姚夢谷先生推崇高逸鴻先生的書畫，有幾句話很精彩：「他在書法上致力的勤奮，與大筆寫意的進境，可算雙管齊下，而互生影響。他的字所以姿縱騰踔，是從寫意畫趣移入。他的畫則是運用書法之長，使水與墨相活用，盡洩水墨畫的奧妙。
● 120幅書畫集 彩色印刷

M039
畫集畫法兼備
趙松泉畫集
趙松泉繪著

大家推崇趙公花鳥畫的原因是：善用疏密，善用冷暖，善用濃淡，善用白粉。103幅供欣賞48幅畫法供初學。

M040
浦蘊秋畫集
繪著者：浦蘊秋

浦蘊秋的工筆花鳥，兼工帶寫，雙鉤與沒骨融為一體，生動富變化，予人俏麗清新、文秀淡潤之感。更擅長仕女人物，功力深厚，畫風閑雅。
● 花鳥42幅 人物62幅 彩色印刷

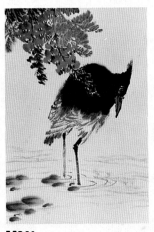

M041
吳平書畫集
吳平繪著

任職故宮博物院書畫處處長。其畫融青藤白陽的灑脫、吳昌碩的拙重、齊白石的簡練為一樽。其書法、篆刻更別具一格，表現出當代人對傳統默默耕耘的深厚情懷。本書收集了他備受推崇的近作，不容錯過！

M042
鄭善禧畫集
鄭善禧繪

這是鄭善禧教授近十年精心創作，以山水花鳥人物為主，他的畫不拘泥於一宗一派，也不受紙筆限制。

M043
邵幼軒畫集
邵幼軒繪著

邵逸軒先生以繪事名故都，其女公子幼軒繼承家學，卓然有成。所作作品設色典雅，婉約有致，是近代花鳥畫名家。本書集編選106幅彩色精印。
● 128頁 彩色106幅 菊8K

M045
● 山禽水鳥・四時花菓，
● 精描細染・形全神好，
● 良工彩印・裝製雅安，
● 學畫範本・玩賞瑰寶。
景年花鳥畫譜
景年編繪

景年花鳥畫譜繪製者今尾景年，為日本花鳥畫老前輩，他繼承中國宋代工筆傳統，由實物寫生出發，觀察細緻，功力精到，用筆豪邁而準確。全書每幅畫面，均以四季花草菓樹與各色飛禽配合。生動自然，為花鳥畫學習最佳範本，亦為案頭展玩最佳珍品。

M046
看齊白石畫
王方宇・許芥昱著

王方宇教授把他珍藏五十幾幅齊白石作品，用考據引經據典方式，把如何欣賞齊白石的作品作引人入勝撰寫。

M047
齊白石彩色精選
齊白石繪著

標榜着「吾畫不為宗派拘束」的齊白石，在傳統和西方之中吸取養料，創出他狂猙、精辟、洗練、堅勁、蒼逸、樸拙的特殊風格。本書刊有他三百餘幅珍品，題材皆以晚年生活之日常所見為主，值得——細賞玩味。
● 220頁 211彩色圖畫

M048
王昌杰畫集
王昌杰繪著

王昌杰的畫，重「創新」，打破傳統中國畫師承的窠臼；涵蓋面極廣，山水草木、鳥獸蟲魚無所不能，風格上則寫意寫實、工筆亂墨無一不精，是他五十年繪畫生涯中本味的凝聚。
●序3篇·彩色81幅·112頁·菊8開

M049
高一峰畫集
高一峰遺著

提起高一峰先生，我們就想起他的邊疆題材作品，駿馬、馴馬、套馬等。他也作了很多以馬為主水墨畫，筆簡意賅，姿態生動。他也作不少早期台灣生活題材，受到大眾喜愛。
●112頁·132彩色圖

M050
虛谷畫集
何恭上編

如謎的身世添增了虛谷和尚藝術的高深莫測。其行徑特立孤獨，藝術遠離凡塵，是海上畫派的崢嶸頭角。畫下的花鳥蔬果、金魚、梅及松鼠，以不落俗套的佈局和筆法取勝，名聞一時。本畫集令您「超凡入勝」！
●120頁·37張黑白圖·61張彩色

M051
王雪濤畫集
王雪濤編繪

王雪濤的寫意花鳥，繪盡了花鳥草蟲的生趣，也表現了寫意花鳥的趣味，他所畫的蜂、蝶、螳螂、天牛、蚱蜢、蝸牛、蜻蜓、青蛙、公雞、鸚鵡、八哥、斑鳩、黃鸝、水鴨、紫鵑、孔雀、鴛鴦、芭蕉、犀牛、黃菊、紫藤……無一不姿態萬千，造型獨特，天趣盎然。本書彩圖100幅。

M054
民初畫家劉奎齡工筆畫選
飛禽走獸花鳥集
劉奎齡繪著

劉奎齡繪畫作品主要特點是描寫對象的精細逼真，一絲不苟，生動有趣，優美感人，這種兼工帶寫意的畫法，非常吸引人。

M056
精印123幅彩色作品
任伯年人物花鳥
任伯年繪

任伯年從工筆畫中解脫出來，形成自己風格的意筆鈎線，結合潑墨和色與墨交溶的方法，頗耐人欣賞。

M057
筆墨精妙·傅彩秀麗
陳之佛工筆花鳥畫集
陳之佛繪著

陳之佛的工筆花鳥，以宋畫嚴謹，徐、黃的技法，從東洋畫的艷麗，摻以寫生技法，創立清新雋逸的典雅風格。

M058
樓閣山水界畫
袁江·袁耀
何如玉編著

本書共選袁江、袁耀的山水樓閣界畫作品12幅，彩色17幅，另彩色刊印袁江所作十二條通景屏「桃花行」和「春來大地」，每條通景屏都有局部放大。袁江、袁耀的山水樓閣界畫並不單純地去表現建築物，而是把自然景物和人工建築很好地配合，雄偉壯觀的山水，富麗典雅的屋宇，二者渾然一體。

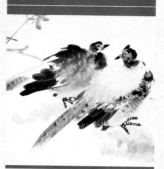

M059
張書旂畫集
張書旂著

張書旂的花鳥畫，呂鳳子曾形容：畫花似聞香，畫鳥若欲語」。他筆下的八哥、游魚、小鴨、鴿子……都以簡筆處理，筆少意繁，獨出機杼，自然生動。本書附中英對照，圖文並茂「書旂畫法」。
●120頁·156幅彩圖·103幅黑白

M062
千嬌百媚
華三川繪著

以華麗富貴的色彩，書法的趣味來刻劃人物的心理，數千年前的美人，便在華三川筆下──甦醒。鶯鶯、二喬、王熙鳳、班昭……千嬌百媚地展現無盡風情，不再是神話或歷史，那令人待到燈火闌珊的美人，就在本書裡。
●90頁 84張彩色 中英對照

M067
吳門畫派
沈以正撰文

明朝的畫壇，蘇州是一個非常特殊地方，明朝四大家沈周、文徵明、仇英、唐寅都在此發展，他們的文采與繪畫形成特殊吳門畫派，也使明朝繪畫有了百年光景的光輝。
●180幅彩圖·80幅黑白·文字4萬

M068
野逸畫派
林秀薇撰文

明末清初一批僧人或看破塵世的畫家像石濤、梅清、石谿、龔賢、髡殘、八大山人，他們在「法給我立」講求獨創，構圖善以變化，筆墨恣肆，意境蒼莽新奇，創造出一片繪畫野逸趣味，對揚州畫派和近代中國畫影響很大。

M069
淸初正統畫派
楊美邠撰文

淸初正統畫家王翬、王原祁、王時敏、王鑒四王加上吳歷、惲壽平亦稱淸大家，他們作品特色淸麗深秀，功力較深，筆墨蒼潤。他們跟同時期石濤等完全呈現對比趣味。

M070
嶺南畫派
王禮溥編著

精選居廉、居巢、高劍父、高奇峯、陳樹人、趙少昂、楊善深、歐豪年、黃磊生名作共計150幅附畫家簡介。

M071
名家册頁畫選

精選陳洪綬的人物，石濤的山水，惲壽平的花卉，李鱓的花卉，居廉的鳥蟲，趙之謙的花卉，任伯年的人物，吳昌碩的花果，黃賓虹的山水，齊白石的畫，十位畫家129幅册頁精品。

花卉畫法 賈寶珉著 藝術圖書公司印行

Series of Chinese Painting Techniques
PAINTING FLOWERS
By Jia Pao-min

M074
花卉畫法
繪著者：賈寶珉

這是學習中國花卉畫最佳進階書，內容包括：①枝幹型花卉畫法②五瓣花卉畫法③多瓣花卉畫法④藤蔓花卉畫法⑤六瓣花卉畫法五大類。共21種花，310幅花卉的畫法與例圖。

● 208頁 彩色印刷 中英對照

M075
選壹佰幅兩宋名畫附說明
兩宋名畫册

宋畫由於當時君王的提倡，掀起院內的工整細緻，與院外的活潑多彩呈現中國繪畫黃金時代。彩色精印。

M076
欣賞近代中國畫的書
近代中國畫選
鍾天山編選

民初畫家齊白石、徐悲鴻、傅抱石、林風眠、張書旂等七位，每位十件到廿五件，全部彩色精印附介紹文。

M077
幫助欣賞中國畫的書
彩色中國名畫
江文雙編譯

民初畫家齊白石畫、花鳥畫、文人畫、海上派畫爲分類法，全部以彩色作品介紹，是本最好欣賞中國畫的書。

國畫入門之二 Steps to Chinese Painting, Book 2 彩色工筆花鳥畫法 Masterpieces of Fine line Paintings of Flowers & Birds

M078
國畫入門之二
彩色工筆花鳥畫法
周天民繪

彩色工筆花鳥畫的實用書，五十張工筆花鳥畫法參考圖，附文字說明，圖文對照。附精美工筆花鳥畫例作。

動物走獸畫譜 編選者：朱文夫 藝術圖書公司印行 國畫入門之一 Steps to Chinese Painting, Book 1 Anthology of Paintings of Animals

M079
國畫入門之一
動物走獸畫譜
劉繼卣編

各種動物鹿、獅、豹、猴、牛、狼、馬、虎、貓……等三十種走獸畫法，並附畫譜順序，也附當代大師近作。

M080
奔馬揚蹄
繪著者：陳永鏘

畫馬的要領，貴於掌握馬的姿態及精神。以工筆及寫意的筆法，勾繪出馬的丰采，不管是單馬、雙馬、群馬或烈馬、馴馬、快馬，無不傳神入化英姿煥發。

M087
東洋畫之美①
竹內栖鳳

他是日本著名畫家，他的畫不但影響日本畫壇，中國嶺南畫派諸大師留學日本時向栖鳳吸收一點亦即成氣候。

M090
東洋畫之美④
上村松篁
劉奇俊編選

日本當代的花鳥畫家中，上村松篁是其中成就卓著的畫家。他的花鳥畫雖然注重寫實，但又不拘泥於自然，在藝術風格上淸新灑脫，蘊育著革新的精神。他的花鳥畫散發著濃厚詩意，在明快溫馨的格調中，含聚著濃濃的詩情。

M095
百鳥畫譜
楊鄂西繪著

假如請您以「棲枝」作爲題材，您能畫出多少幅花鳥畫？楊鄂西以單一的題材，寫出百鳥獨特的風姿、色彩，使每幅畫皆飛揚著動人的想像力和創造力。本書綜合運用了勾勒、潤筆、潑墨、暈染等技巧，指導初學者走入繽紛自由的世界。

● 218頁 208張彩圖 2萬字

M098
古詩畫意
編著者：宗文龍

精選古詩72篇，通過畫畫家匠心獨具、著意構思的傳神之作，配以中英日三種文字。古詩新繪，趣味盎然，饒富深情，再現中國詩書畫之美。

奔馬揚蹄
The Way to Paint Horses

國家圖書館出版品預行編目資料

張書旂畫集／張書旂繪著. --初版. --臺北
　市：藝術圖書，1999 [民88]
　面；　　公分. --(畫好國畫；59)

　ISBN 957-672-308-6 (平裝)

　1. 繪畫-中國-作品集　2. 繪畫-中國-技法

945.6　　　　　　　　　　　　88011071

畫好國畫 **59**

張書旂畫集附畫法

繪著者：張書旂

法律顧問●	北辰著作權事務所
●	蕭雄淋律師
發 行 人●	何恭上
發 行 所●	藝術圖書公司
地　　址●	台北市羅斯福路3段283巷18號
電　　話●	(02)2362-0578・(02)2362-9769
傳　　眞●	(02)2362-3594
郵　　撥●	郵政劃撥 0017620-0 號帳戶
南部分社●	台南市西門路1段223巷10弄26號
電　　話●	(06)261-7268
傳　　眞●	(06)263-7698
中部分社●	台中縣潭子鄉大豐路3段186巷6弄35號
電　　話●	(04)534-0234
傳　　眞●	(04)533-1186
登 記 證●	行政院新聞局台業字第 1035 號
定　　價●	480 元　　特價書不退換
再　　版●	1999年 8 月30日

ISBN　957-672-308-6